# EDINBURGH

## IN

# 50

## BUILDINGS

## JACK GILLON

AMBERLEY

First published 2017

Amberley Publishing, The Hill, Stroud
Gloucestershire GL5 4EP

www.amberley-books.com

British Library Cataloguing in Publication Data.
A catalogue record for this book is available from the British Library.

ISBN 978 1 4456 6170 4 (print)
ISBN 978 1 4456 6171 1 (ebook)

Origination by Amberley Publishing.
Printed in Great Britain.

# Contents

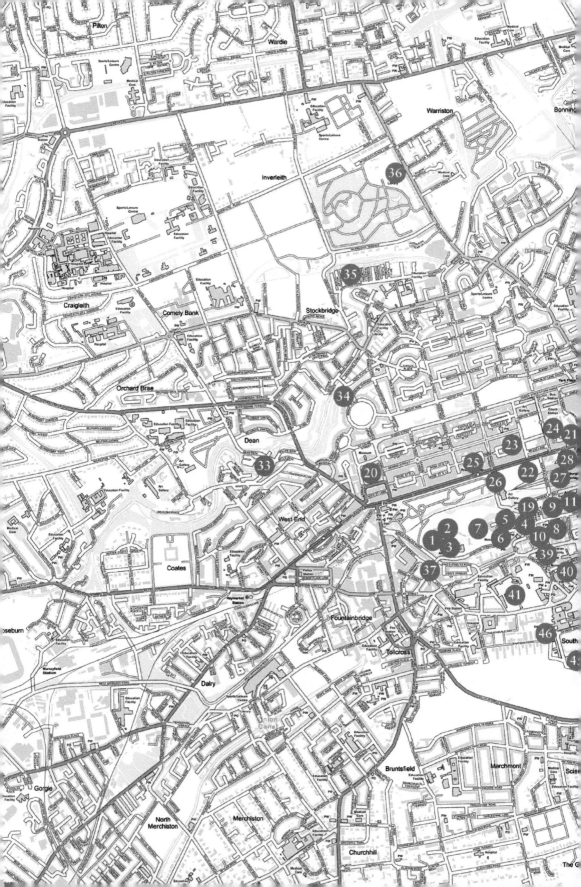

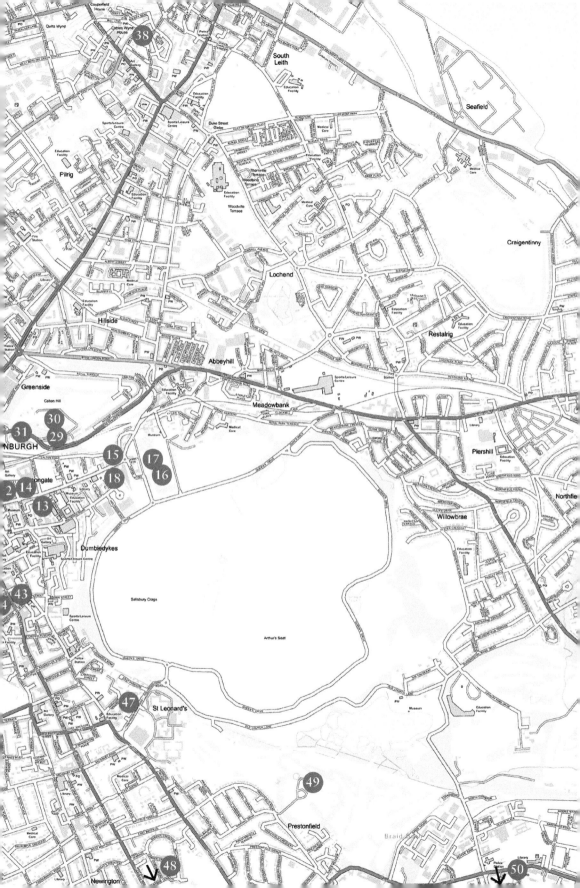

# Introduction

Living in Edinburgh there abides above all things, a sense of its beauty. Hill, crag, castle rock, blue stretch of sea, the picturesque ridge of the Old Town, the squares and terraces of the New these things once seen are not to be forgotten.

Alexander Smith, *A Summer in Skye*, 1864

Edinburgh is a city that evokes strong reactions. Queen Victoria considered Edinburgh to be 'quite enchanting and fairy-like'. It was Sir Walter Scott's 'own romantic town', Robert Louis Stevenson's 'dream in masonry and living rock' and Hugh MacDiarmid's 'mad god's dream'. Samuel Johnson thought it 'would make a good prison in England' and more ominously Dr Joseph Goebbels considered it 'enchanting – a delightful summer capital when we invade Britain'.

The city contains a wealth of architectural heritage – the Old Town retains much of its medieval character and the Georgian New Town, with its regular facades and major neoclassical buildings by architects of the stature of Robert Adam, is one of the world's most extensive examples of a neoclassical town. The contrast and proximity between these two distinct areas resulted in them being declared a World Heritage Site in 1995.

Edinburgh also has the greatest concentration of buildings formally recognised as being of historic or architectural importance in Scotland, with around 5,000 listed items comprising more than 30,000 separate buildings. These range in scale from the massive Forth Bridge to the diminutive statue of Greyfriars Bobby, and in age from the twelfth century to the late twentieh century.

With this wealth of heritage, the task of selecting fifty buildings to represent the city's rich architectural legacy has been immensely difficult. The book takes the development of Edinburgh from its earliest times as its broad theme, and describes buildings that seem to best reflect the city's long history.

# The 50 Buildings

## 1. Edinburgh Castle

> The Castle on the lofty rock is so strongly grounded, bounded and founded, that by force
> of man it can never be confounded.
>
> John Taylor, *Pennyless Pilgrimage, 1618*

Edinburgh Castle is the pre-eminent building of historic and architectural importance in Edinburgh and Scotland's most popular tourist attraction. Dramatically situated on its precipitous crag, standing 100 metres above Princes Street, the turreted and battlemented complex of buildings tower over the city centre and dominate the skyline. It is an internationally renowned compelling architectural symbol of Edinburgh and Scotland.

The Castle Rock is the hard core of a 350-million-year-old extinct volcano, buried and subsequently revealed by the erosion of glaciers in the last ice age. The eastward flow of the ice left the distinctive crag and tail formation of the Castle Rock and the Old Town Ridge, together with parallel valleys to the north and south. Protected on three sides by steep cliffs, it was a formidable defensive site. The Castle Rock was first settled in prehistoric times and for hundreds of years was little more than a fortified prominence. It is first mentioned as Dineidin in a sixth-century Welsh poem. A royal castle was present from at least the tenth century and the first buildings in Edinburgh were hard by the castle, which was large enough to protect many people and strong enough to ensure their defence.

It has had a turbulent history – captured from the English and destroyed in 1314 by the Earl of Moray, ruined for the next twenty-one years, rebuilt in 1335 by Edward III, destroyed again by the Scots six years later, rebuilt by David I around 1360 and damaged by cannons during the Long Siege of 1570–73.

The castle has performed many different roles over the centuries – royal residence, barracks, munitions factory, prison – and is now an enormously popular tourist attraction. The individual buildings have been witness to major events in Scotland's eventful history and represent the different centuries and functions. It is dominated on its east side by the massive retaining wall of the Half Moon Battery, built in 1574, and by the sixteenth-century King's Lodging, which housed the Royal Apartments. The massive Georgian New Barracks, completed in 1799, towers over the west side of the crag.

The castle is the home of the Honours of Scotland – the royal crown, sceptre and sword of state. In 1566, in a tiny room in the King's Lodging, Mary Queen of Scots gave birth to the future King James VI, who was to become King James I of England after the Union of the Crowns in 1603.

The esplanade forms the entrance to the castle and is the dramatic setting for the military tattoo. It was laid out in 1753 as a parade ground and completed in its present form in 1816. There is a row of military monuments on its north side and it commands panoramic views to both the north and south. It seems that the castle esplanade was ceded to Nova Scotia in 1624 by a treaty that has never been repealed and is still legally Nova Scotian territory.

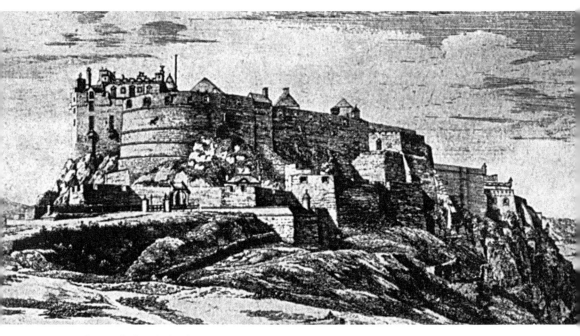

*Above*: Edinburgh Castle in 1750.

*Below*: Edinburgh Castle from the Esplanade.

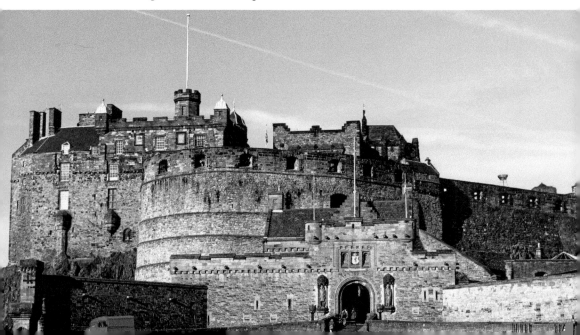

## 2. St Margaret's Chapel, Edinburgh Castle

The diminutive ancient Romanesque chapel dedicated to St Margaret stands at the highest point of Edinburgh Castle and is the oldest surviving building in the city.

It was built in the first half of the twelfth century during the reign of one or other of St Margaret's younger sons, David or Alexander. Queen Margaret (1045–93) was the wife of Malcolm III of Scotland – already ill, she died on hearing of the death of her husband at the Battle of Alnwick. She was canonised by Pope Innocent IV in 1250 for her charitable work and religious fidelity.

The 'Royal Chapel in the Castle' originally formed part of the royal lodgings and was used for religious services. The chapel was saved on the orders of King Robert the Bruce, when the castle was demolished in 1314 to prevent it from being taken by English forces.

From the sixteenth century, following the Reformation, it was used as a munitions store. The significance of the buildings was rediscovered in 1845 by the antiquarian Sir Daniel Wilson and it was partly restored in 1853.

The striking stained-glass windows depicting St Andrew, St Columba, St Margaret and Sir William Wallace were installed in 1922. A further restoration brought the building back into use and it was dedicated on 16 March 1934. Another restoration of the building was carried out in 1993 to commemorate the 900th anniversary of the death of St Margaret.

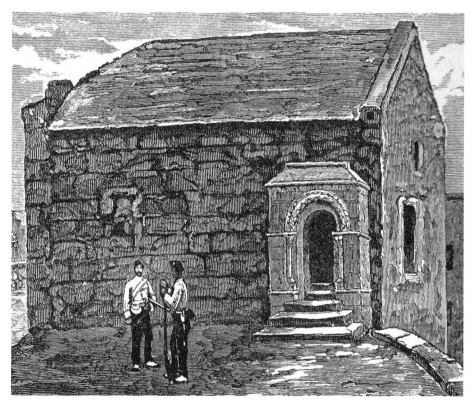

St Margaret's Chapel.

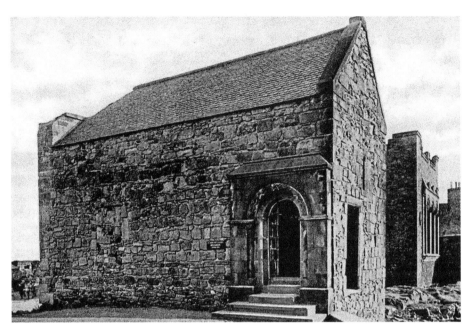

St Margaret's Chapel.

## 3. Scottish National War Memorial, Edinburgh Castle

> I find it more difficult to write about Scotland's National War Shrine than about anything I
> have ever attempted to describe. There is nothing like it in the world: it is the soul of Scotland.
>
> *H. V. Morton*

Few families in Scotland were not touched in some way by the impact of the First World
War and the Scottish National War Memorial commemorates the sacrifices of nearly
150,000 Scots in the conflict. It was designed by Sir Robert Lorimer (1864–1929) and
stands on Crown Square at the summit of the Castle Rock on the site of a barracks block
that had replaced the ancient St Mary's Chapel.

A semicircular flight of steps, flanked by a heraldic lion and unicorn, leads up to the
entrance porch of the memorial. The exterior gives little hint of the stunning and poignant
interior, which includes a frieze carved with the names of First World War battlefields and
sumptuous stained glass.

It was paid for by public subscription in Scotland and worked on by hundreds of Scottish
craftsmen. The memorial was opened by the Prince of Wales on 14 July 1927 – the King
had made it a policy not to open any war memorials, but, shortly after the inauguration,
the King, Queen and Princess Mary laid wreaths outside the building and placed the Rolls
of Honour, with the names of Scots killed in the Great War, in a casket, which forms the
centrepiece of the memorial.

At the time of its construction, it was believed by many that the memorial would be a
shrine to the 'war that ended war', and it is sad to reflect that it now also commemorates
the more than 50,000 Scots fatalities in the Second World War and conflicts since then.

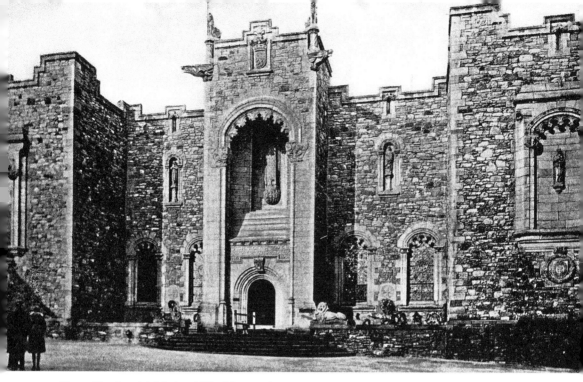

*Above*: The Scottish National War Memorial.

*Below*: The Shrine, Scottish National War Memorial.

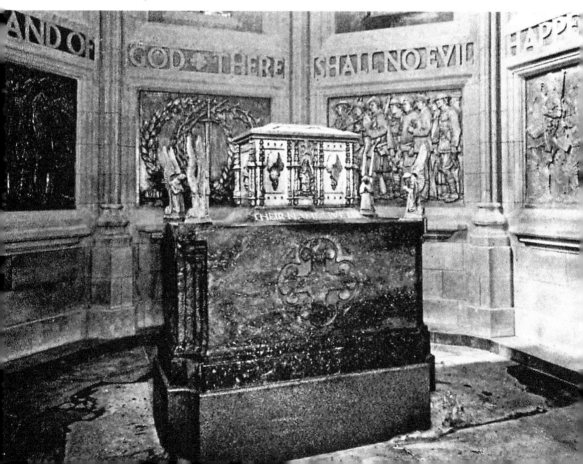

## 4. Gladstone's Land, 483–489 Lawnmarket

The population of Edinburgh gradually increased within the restrictive town walls during the seventeenth and early eighteenth centuries. Separate medieval settlements, Edinburgh and the Canongate, developed – Edinburgh contained the tallest series of urban domestic buildings of their time, which contrasted with the larger houses and generous gardens of the more spacious Canongate.

Edinburgh's early multistorey buildings are typified by the seventeenth-century restored tenement of Gladstone's Land. The distinctive tall and narrow six-storey building with its arcaded ground floor, a practical arrangement providing shelter for the shop stalls; curved stone forestair and small-pane leaded glazing over timber shutters is one of the finest and most original surviving examples of an early seventeenth century tenement (land means a tenement) building in the Old Town.

The original house, which dated from 1550, was purchased by Thomas Gledstanes (Glaidstanes), a wealthy merchant, on 20 December 1617. Gledstanes significantly redeveloped the original building in two stages. In 1620, the building was extended forward with a wooden frontage, providing an additional room on each floor, and, in 1631, a new ashlar frontage supported by an arcaded ground floor was added.

The dignified arcaded frontage is the only surviving example of what was previously a common feature of Old Town houses. They developed from the overhanging timber galleries, which were replaced from the end of the sixteenth century by stone. There was a requirement to maintain a covered passage for pedestrians to pass along the street under cover and the new stone frontages were supported by arcades with the main ground-floor frontage set back.

Gledstanes married Bessie Cunningham on 27 August 1607 and the western skewputt is inscribed with their initials – the skewputt to the east is inscribed with a saltire. The *Gled* in Gledstanes is derived from the old Scottish word for a hawk and the sign above the entrance includes a gilded hawk.

In the early nineteenth century many of the wealthier Old Town residents had decamped to more salubrious houses in the New Town and properties in the Old Town, including Gladstone's Land, were neglected and spiralled into dereliction. By the 1930s, *Gladstone's Land* was a dilapidated slum subdivided into as many as twenty-four separate units and was programmed for demolition. In 1934, it was rescued by Miss Harrison, a philanthropic local resident, who donated it to the National Trust for Scotland. It was restored by Sir Frank Mears and leased to the Saltire Society.

In 1978, a more extensive restoration programme under the direction of Robert Hurd and Partners to convert it into a museum of Old Town life was commenced. This revealed the arcaded frontage, which had been covered by a later addition shopfront. Hurd carried out further work in 1978–80, which restored the timber shop booth behind the arcade and the historic window pattern. The restoration of the interior included the removal of multiple layers of paint, which revealed a finely detailed painted frieze, ceilings and shutters that are considered among the best seventeenth-century examples in Scotland.

The authentically restored and furnished building is a popular tourist attraction offering a taste of life in seventeenth-century Edinburgh and providing a striking contrast with the Trust's Georgian House at No. 7 Charlotte Square.

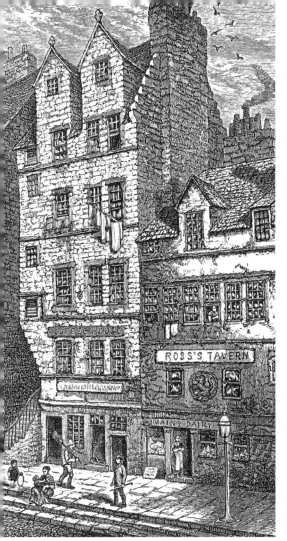 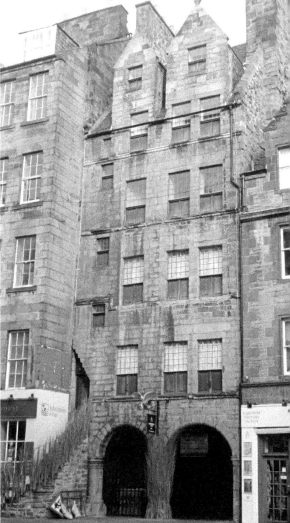

*Above left*: Gladstone's Land.

*Above right*: Gladstone's Land.

## 5. Mylne's Court

The Old Town is characterised by the survival of a series of tightly packed, little-altered, narrow closes branching out in a fishbone pattern from the main spine of the Royal Mile – a sequence of five historic streets (Castlehill, Lawnmarket, High Street, Canongate and Abbey Strand). In the mid-eighteenth century there were around 400 closes in the Old Town; there are now approximately 100.

James Gordon of Rothiemay's plan of 1647 gives an impression of how closely built up the streets in Edinburgh were at the time – the site of Mylne's Court is behind the Weigh House marked as 10 on the illustrated section of the plan. The plan is an idealised version of life on the ground, which would have been significantly more tightly packed. Fire was a constant problem and the standard of basic hygiene was minimal.

There were still many affluent residents in the Old Town who generally occupied the middle floors of tenements, which were reasonably distant from the frequently unwholesome conditions of the street. In the latter part of the seventeenth century, Robert Mylne, who had been appointed Master Mason to the Crown in 1668, saw the potential of creating more salubrious residential accommodation in the crowded streets of the Old Town.

Mylne started to purchase ruinous tenements fronting the Lawnmarket and erected blocks of tenements around three sides of a new spacious quadrangle. The concept of an open courtyard was a new idea for Edinburgh and the accommodation provided in the flats represented major improvements in living conditions

Mylne's Court is the earliest remaining example in Edinburgh of an open court and is not to be confused with Mylne's Square, which stood opposite the Tron Kirk and was demolished in the 1890s for the widening of North Bridge.

As was the case with many Old Town properties, Mylne's Court fell into a general state of decline in the eighteenth and nineteenth centuries with the removal of more affluent residents to the New Town. The flats were subdivided, and there was a general decline in both the social and physical condition of the buildings.

In the twentieth century, the quality of the building was recognised and there were a number of phases of restoration. In the period 1966–70, Mylne's Court was restored and reconstructed by Ian Lindsay and Partners as halls of residence for the University of Edinburgh.

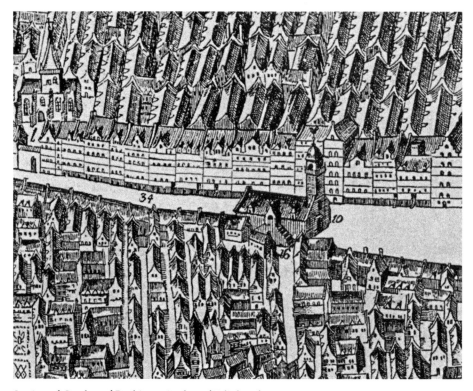

Section of Gordon of Rothiemay's plan of Edinburgh.

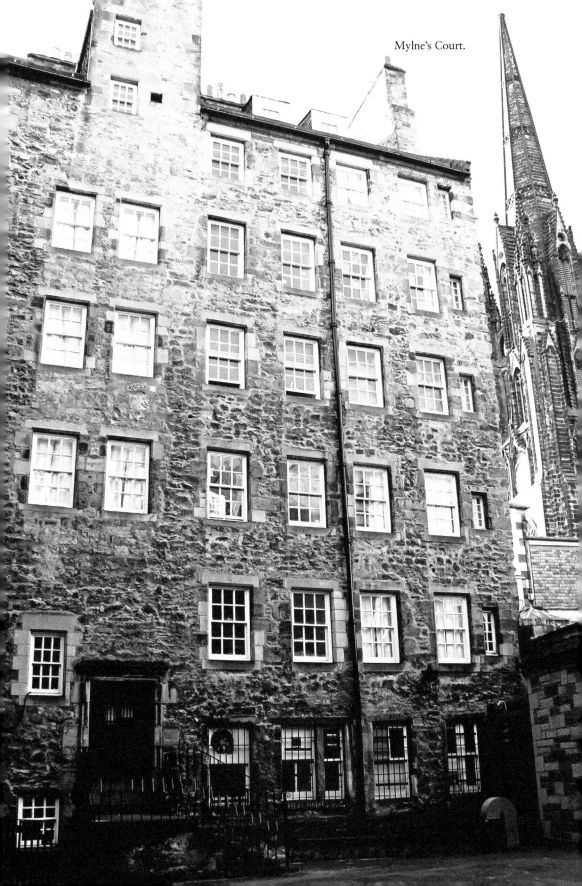

Mylne's Court.

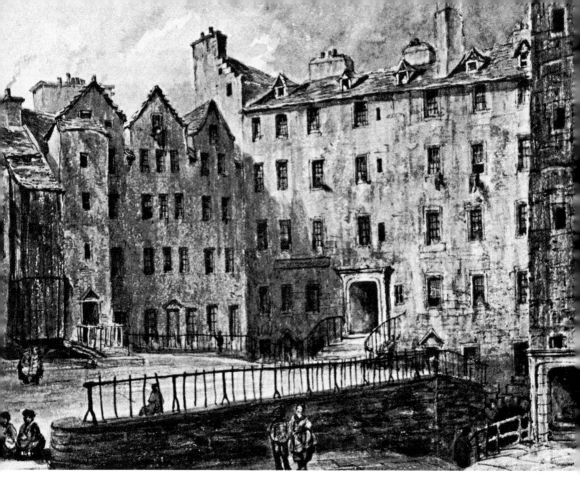

Mylne's Court in the early nineteenth century.

## 6. The Outlook Tower, Castlehill

In 1853, Maria Theresa Short moved her exhibition of scientific instruments from Edinburgh's Calton Hill to new premises at the top of Castlehill. She transformed the seventeenth-century building, which was traditionally believed to be the town mansion of Ramsay of Dalhousie, the 'Laird of Cockpen', into Short's Observatory by the addition of two floors. Exhibits included 'a powerful galvanic machine which gives shocks of any power, a Fairy Fountain of Electric Water and a Wonderful Electric Boy'. However, the main attraction was the camera obscura, a periscope device of mirrors and lenses, which projects a moving image onto a reflective table.

In 1892, the building was taken over by Patrick Geddes (1854–1932). Geddes was officially a botanist and biologist, but was involved in a multitude of other activities, and is best remembered as the 'father of modern town planning'. There are many places throughout the world that bear traces of the influence of Geddes. In Edinburgh, he was responsible for setting up the first student hostel in Scotland, designing the zoo, building Ramsay Garden, establishing community gardens and other improvement schemes in the Old Town.

Geddes intended to transform the building into the 'world's first sociological laboratory' – a 'place of outlook as a key to a better understanding of Edinburgh and its region, but also to help people get a clear idea of its relation to the world at large'.

Geddes believed that a tour of the Outlook Tower should begin at the top of the building on the flat roof terrace where a general idea of the Edinburgh region and 'one of the great views of the world' could be seen. The camera obscura then provided a different view of the outside environment, in the 'miniature-like perfection of detail' reflected in the moving image on the screen. After this 'lesson in the art of seeing' it was felt that 'quiet reflection and meditation on the many new impressions which had been gathered' would be required, so a small darkened room with a single chair was provided.

Each lower storey of the tower was devoted to exhibits and collections of material relating to the world, Europe, language, Scotland and Edinburgh. Exhibits included an episcope, which provided a view of the world 'as if it were suddenly to become transparent beneath one's feet', a hollow globe and a celestial sphere. All of these were intended to show the relation of the world to its surroundings in the universe.

The Edinburgh Room had a relief model of the city and illustrations showing its architectural development. In the Scotland Room the evolution of the Scottish nation was traced on a large floor map.

The Outlook Tower retained its educational function for a number of years and a larger camera was installed in 1945. The camera obscura remains a popular tourist attraction.

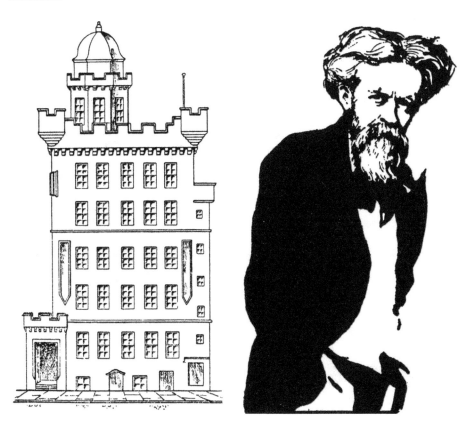

*Above left*: The Outlook Tower.

*Above right*: Sir Patrick Geddes.

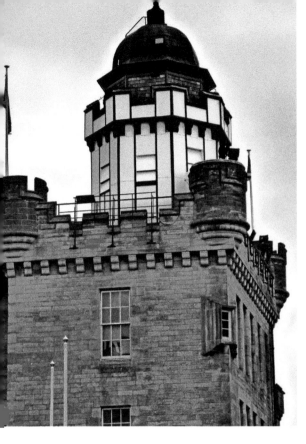

The Outlook Tower.

## 7. Ramsay Garden

Ramsay Garden, with its cream harling, red-sandstone dressings, steeply pitched red-tiled conical roofs, half timbering, oriel windows, projecting stair towers and balconies, crowsteps and emblematic carvings, forms a superbly exuberant and idiosyncratic addition to the Old Town skyline, cascading down the north side of the ridge. The architecture incorporates a fascinating mixture of styles – it has been described as Arts and Crafts, Baronial, Scottish vernacular, English cottage, Teutonic and Celtic revival – but still somehow seems to reflect Edinburgh's medieval character.

It was the brainchild of Sir Patrick Geddes. Geddes lived in the Old Town and promoted a wide range of sympathetic regeneration projects along the length of the Royal Mile. These involved a more piecemeal approach to slum clearance – a minimum intervention methodology of small-scale changes within the existing street pattern, which he called 'conservative surgery'. This approach was adopted in the City Improvement Act of 1893, which was a reaction to the comprehensive redevelopment of earlier improvement schemes. The idea was to minimise the loss of existing buildings and retain local residents.

Ramsay Garden was built between 1892 and 1894 to designs by Stewart Henbest Capper and Sydney Mitchell. It incorporated the eighteenth-century Ramsay Lodge, known as the 'Goose-pie' from its unusual octagonal shape, which was the home of wig-maker and renowned poet Allan Ramsay (1686–1758).

The original principal use of Ramsay Garden was as halls of residence for students – a community for academics, with a number of prestigious flats, which were intended to

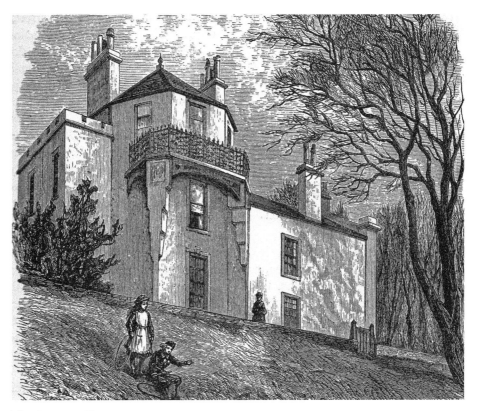

The Goose Pie House.

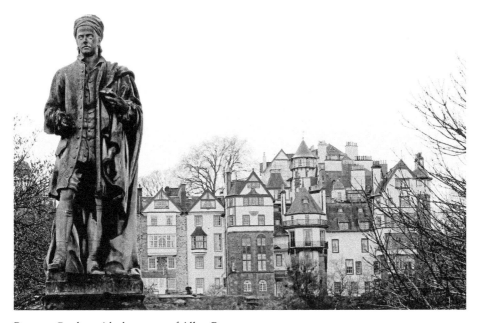

Ramsay Garden with the statue of Allan Ramsay.

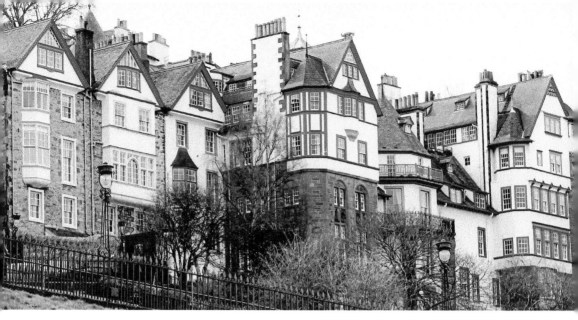

Ramsay Garden.

attract academics and professionals back into the Old Town. Geddes had an impressive twelve-room flat in the building.

The roof of one of the buildings is capped by a distinctive sculpture of what was originally designed as a devil, but now looks more like a cat. There were originally two other sculptures – of an angel and a sphinx – on the roofs, which Geddes intended to signify the riddle of life.

## 8. St Giles (High) Kirk, High Street and Parliament Square

The area around Parliament Square, which was built in 1632 as the forecourt of Parliament House, is the traditional site of the Three Estates: the three main functions of state in Scotland – Church, Parliament and Law.

St Giles, the High Kirk of Edinburgh, has its origins in the mid-twelfth century and has been the central feature of the Old Town for nearly 800 years. It is named after a seventh-century hermit – the patron saint of cripples, beggars, lepers and blacksmiths – and was built on an older ecclesiastical site.

It has gone through numerous changes in the course of its long history and has been added to in a piecemeal fashion. The church was rebuilt after it was burned down by Richard II in 1385 during the sacking of Edinburgh and the core of the building dates from the fourteenth century. The landmark crown spire surmounted by a gilded cockerel and supported by eight flying buttresses was added around 1495 and rebuilt in 1646.

It was converted for Presbyterian worship during the Reformation and John Knox served as minister from 7 July 1559 until his death in 1572. It was briefly an Episcopal cathedral between 1633–38 and 1661–89, which was not popular with many Edinburghers. On Sunday 23 July 1637, Jenny Geddes, an Edinburgh cabbage seller, famously threw a stool at the minister (this was a time when there were no seats in churches and worshippers provided their own) who was reading from the English prayer book (the Laud's Liturgy).

Jenny is said to have shouted 'False thief, will you say mass about my lug.' The result was a riot, the National Covenant and civil war, during which many Covenanters were persecuted

The church was subdivided for the use of four different congregations in the seventeeth century – the High Church, the Old Church, the Tolbooth Church, and the New North, Little or Haddo's Hole Church – and fell into a state of disrepair. The removal of the Luckenbooths, a ramshackle group of buildings that ran parallel to the church for the full length of its north side, in 1817 revealed the poor condition of the building.

In 1829–33, the frontage of the church was rebuilt and given a new dressed stone facade in an overenthusiastic restoration by William Burn. Much of its medieval character was lost at this time – fortunately funds ran out before the work extended to the open crown steeple, which retains its medieval masonry and dominates the Old Town skyline. The internal partitions were not fully removed and a single space created until a further restoration scheme in 1881–83.

The small, exquisitely decorated Chapel of the Most Ancient and Most Noble Order of the Thistle, with its elaborate decoration, including elegantly carved representations of angels playing bagpipes, was added by Sir Robert Lorimer in 1910.

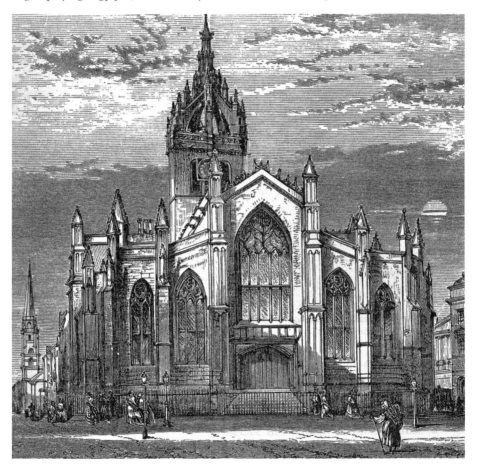

St Giles.

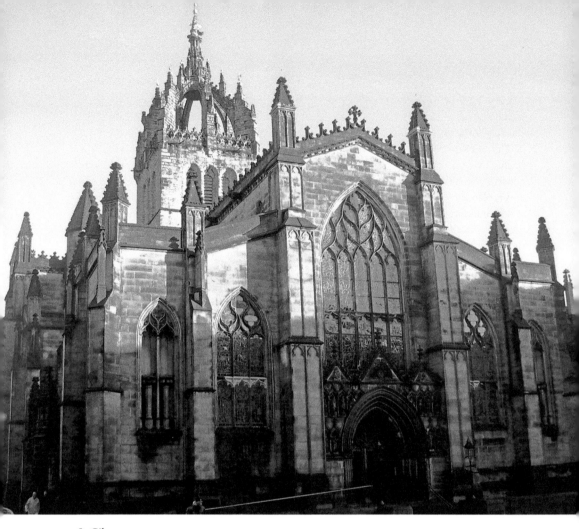

St Giles.

## 9. City Chambers, High Street

In 1680, Thomas Robertson built an Exchange at his own expense on the south-east corner of Parliament Square for the Edinburgh merchants. This was destroyed by a fire in 1700 and the city merchants then transacted their business beside the Mercat Cross. In 1750, the area around the statue of Charles II was allocated as their meeting place. However, it was considered that the city needed a proper Exchange.

The Royal Exchange, now the City Chambers, was originally built as a place of business for the city's merchants, and included a customs house, shops, coffee houses, dwelling houses and offices. It was 'the first symptom of vitality in Edinburgh after the Union' – the first of a planned series of improvements to the city, which were intended to 'raise Edinburgh in elegance superior to most other cities'.

The foundation stone was laid on 13 September 1753 by Lord Provost George Drummond in front of 'the greatest concourse of people assembled that had ever been known before in the metropolis'. Four old ruinous closes – Mary King's, Stewart's,

Pearson's and Allan's – were demolished for the development, although part of Mary King's Close survives at the lower levels of the building – the walls of the ancient building were so well constructed that they were used as the foundations of the Exchange. The rubble from the demolished buildings was used to construct the castle esplanade.

The original plans were prepared by John Adam, but were amended by John Fergus during the course of construction with the addition of an arcade closing off the three-sided courtyard. The original arcade, which had a central entrance arch with shops on each side, was replaced by the current open rusticated screen in 1901.

The building is four storeys on the High Street frontage, but has twelve storeys rising to 36 metres to the north, due to the sharp drop into Cockburn Street to the rear – it is one of the tallest buildings in the Old Town.

The new Exchange was never popular with the Edinburgh merchants, who preferred to do business on the High Street: 'notwithstanding the convenience of the square of the Exchange for merchants to meet in, and its vicinity to the Cross, they still prefer standing in the street, in defiance of all attempts to induce them to do otherwise' (*Picture of Edinburgh*, J. Stark, 1821).

From 1810, when the old tolbooth was demolished, the building was progressively occupied by the town council. Significant alterations have been carried out over the years and the east and west wings to the High Street were built in the 1930s.

The statue in the quadrangle depicts a young Alexander the Great taming his horse, Bucephalus.

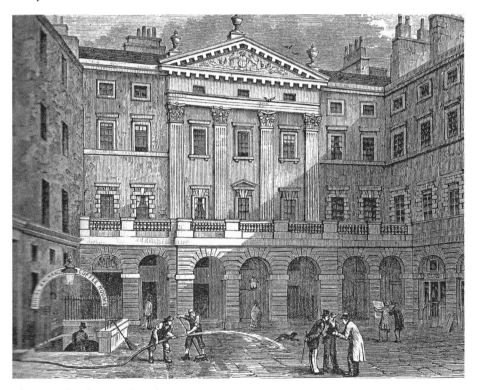

The City Chambers quadrangle.

The City Chambers on Cockburn Street.

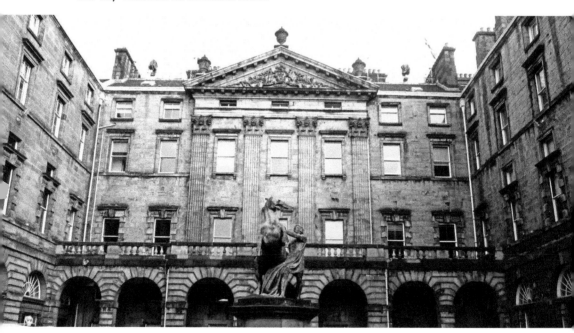

The City Chambers quadrangle.

## 10. Parliament Hall, Parliament Square

Before the Treaty of Union of 1707, Scotland had its own parliament, which, from 1639, met at what was then the newly purpose-built Parliament Hall. Prior to this it had a fairly unsatisfactory home in the old tolbooth, sharing the space with prisoners, the law court and the town council.

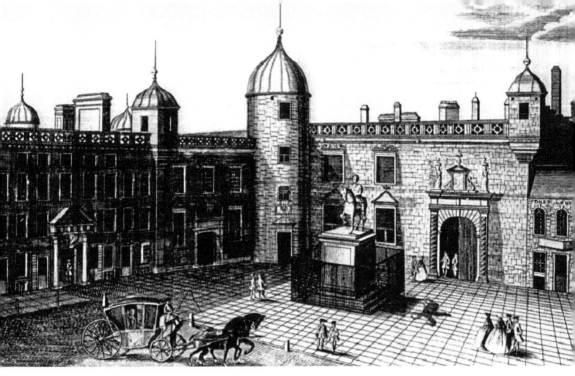

*Above*: Parliament Hall in the seventeenth century.

*Below*: Parliament Hall.

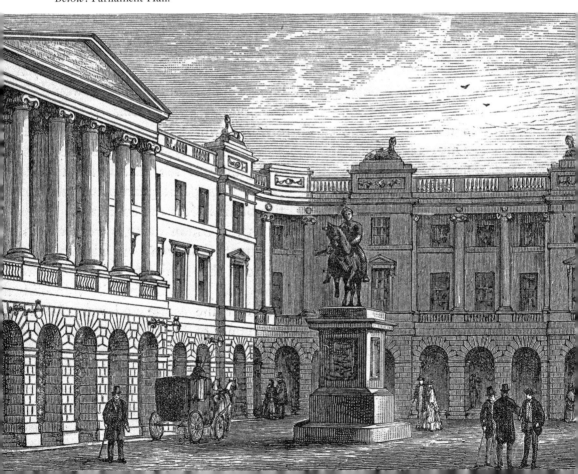

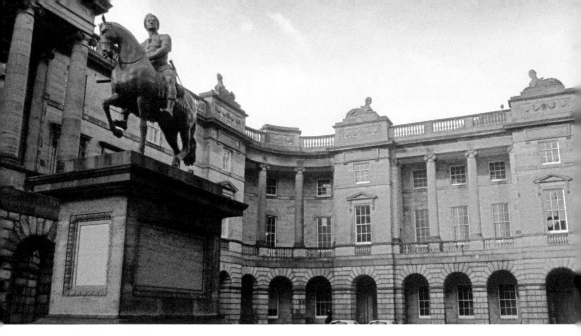

Parliament Hall.

The town council had agreed to provide a new building for the parliament in 1631, after a proposal to move the law courts to St Andrews. It was built to a design by Sir James Murray, the King's Master of Work, and was described as a 'luscious assemblage of turrets and moulded details– part of a careless phase of unserious fortifification'.

After 1707, the building was used by the law courts and at the start of the nineteenth century it was enlarged and given a classical facade by the architect Robert Reid. The original hall, with its intricate seventeenth-century open-beam oak-trussed roof, remains – it is known as the 'Floor' and is used by advocates discussing cases with their clients.

The imposing lead equestrian statue of King Charles II (1630–85) in the garb of a Roman emperor was presented to Edinburgh by James Smith, the Surveyor of the King's Works, in 1685 as a tribute to the king. It is the oldest statue in Edinburgh, and one of the oldest lead statues in Britain.

## 11. Cockburn Street

During the nineteenth century, Edinburgh went through a period of rapid industrialisation and urbanisation. Reports on the Old Town of Edinburgh in the 1840s documented that the area had the most unsanitary living conditions of any city in Britain. The collapse of Smith's Land, a tenement on Edinburgh's High Street, on the 24 November 1861, when thirty-five people were killed, brought the issue of the condition of buildings in the Old Town into sharp focus.

Around the mid-nineteenth century, Edinburgh was also affected by a recession, the result of which was that between 1825 and 1860 virtually no new houses were built. It was reckoned that 'overcrowding in the Blackfriars area was four times greater than in prison cells' in this period; the *Edinburgh News* went so far as to describe Old Town houses as 'chambers of death'. In 1850, it was noted at the Reform Association that

'the unclean heart of Edinburgh would not be gutted out until it was planted all around with new houses'.

The Improvement Acts of the nineteenth century in the Old Town, in which the older tenements were replaced with new buildings, were seen as a solution to the problem. The improvements resulted in a number of new streets, which sliced through the previous medieval pattern of closely packed closes in the Old Town.

The architectural form that was adopted for many of the new buildings was the Scottish Baronial, which was inspired by the buildings of the Scottish Renaissance, reflected a revived interest in the exploration of national identity and was seen as an expression of Scottish architectural tradition. It was used extensively as architectural camouflage for the redevelopment schemes in the Old Town and Cockburn Street is one of the best examples.

Cockburn Street was originally named Lord Cockburn Street for Henry Cockburn (1779–1854), who sat in the Court of Session as Lord Cockburn, and who was particularly noted for his concern for the conservation of Edinburgh. Cockburn Street was planned, in the year of Lord Cockburn's death, by Peddie and Kinnear for the Edinburgh Railway Station Access Co., under the Railway Station Acts of 1853 and 1860, to provide access to Waverley Station from the High Street. The Acts stipulated that it was 'desirable to preserve as far as possible the architectural style and antique character of the buildings of that part of the Old Town in the line and neighbourhood of the new street'.

Construction of Cockburn Street began in 1859. It sensitively sliced through the previous medieval pattern of closes in a serpentine curve to provide a more gentle gradient and wider street. The buildings are festooned with a vigorous array of Baronial details – crow-stepped gables, corbelling, oriel windows and turrets.

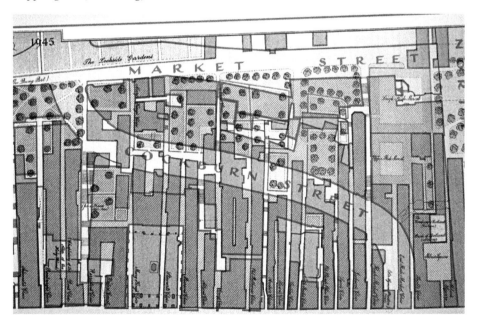

Plan showing how Cockburn Street cut through the medieval layout.

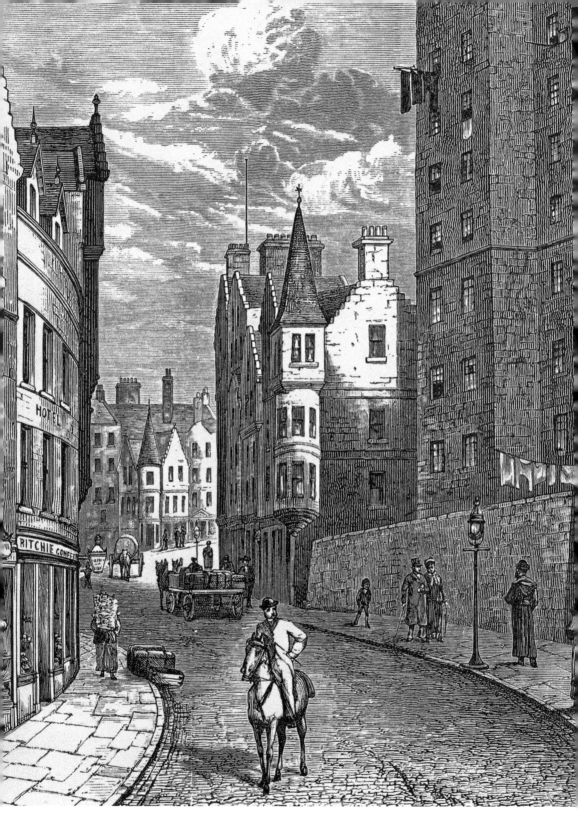

Lord Cockburn Street.

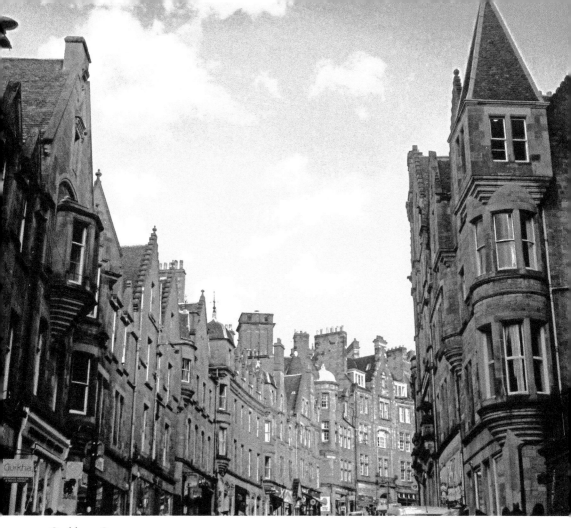

Cockburn Street.

## 12. John Knox House, High Street

The picturesque John Knox House is a fine example of a historic merchant's house and of the earliest domestic architecture in Edinburgh. It is a conspicuous building standing forward of the street building line with its forestair and jettied timber galleries, which are the last remaining examples in the city.

It dates mainly from the sixteenth-century, incorporating an earlier fifteenth-century core and is the earliest surviving tenement in Edinburgh. It was built by James Mosman, goldsmith to Mary Queen of Scots, and bears his initials and those of his wife, Mariota Arres. The inscription *Lufe God abufe al and yi nyghbour as yi self* is inscribed above the entrance door and there is a carved figure of Moses above a sundial on the corner. Mosman was executed for treason in 1573 (it seems that Queen Elizabeth took exception to him pawning the crown jewels and he was hung, drawn and quartered at the Mercat Cross), so it is a safe assumption that the bulk of the sixteenth-century work dates from before this date.

The question whether the firebrand preacher John Knox ever lived in the house has been hotly contested, although there is a tradition that he was resident shortly before his death

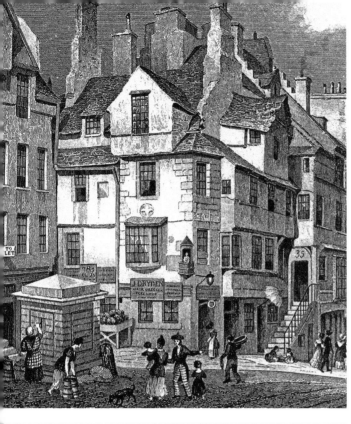

John Knox House.

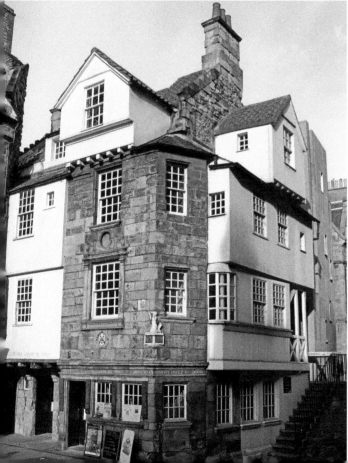

John Knox House.

on 24 November 1572 and there are stories of him preaching from the balcony of the house. It is said that he was asked in his last moments 'Have you hope'. Unable to speak he lifted his finger, pointed upwards and passed away.

The house was in a dilapidated condition during the 1840s and in 1849 was considered for demolition for road widening. The Society of Antiquaries championed the retention of the house and its preservation had much to do with its association with Knox. The building was restored in the mid-nineteenth century, turned into a museum and has been a tourist attraction since that period. It now forms part of the Netherbow Arts Centre.

Moubray House, with its elegant curved forestair, to the west of John Knox's House, is another important early tenement. It originally dates from 1477, but was reconstructed in the seventeenth century when it was in use as a tavern. Daniel Defoe, the author of *Robinson Crusoe*, was one of its residents.

## 13. Acheson House, No. 40 Canongate

Acheson House was built for Charles I's Secretary of State for Scotland, Sir Archibald Acheson, and his wife, Dame Margaret Hamilton, in 1633–34. This was a time when the Canongate, with its proximity to Holyrood, was particularly favoured by the Scottish nobility and aristocracy. It would have been intended to reflect Acheson's status as an important adviser to the king – although Sir Archibald passed away on 9 September 1634, before the completion of his new mansion.

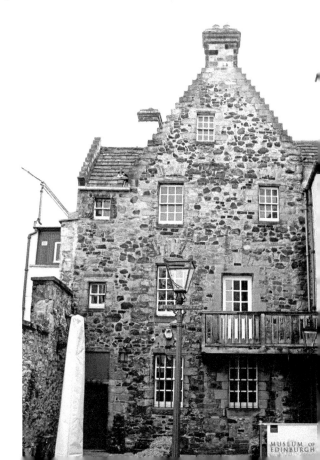

Acheson House.

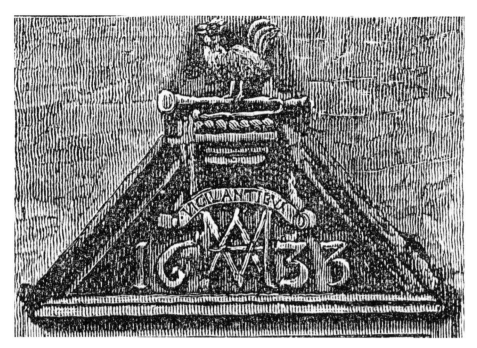

Carved pediment at Acheson House.

The house, with its setback frontage and walled forecourt, reflects the lower density of development in the Canongate at the time and is an exceptionally fine example of a large, early seventeenth-century Scottish town house. The pediment above the stair-tower door has the date 1633, the Acheson family crest of a cock and trumpet and the inscribed initials of Acheson and his wife.

After Acheson's death, the house had numerous owners and was divided into a tenement for multiple occupants. During the second half of the nineteenth century, it was one of Edinburgh's most infamous bordellos, known as the Cock and Strumpet – a play on the motto on the Acheson's family crest.

In the early part of the twentieth century, it was again in use as a tenement, occupied by fourteen families – with a public convenience and small cottage in the courtyard.

In 1924, Acheson House and the adjoining Huntly House were purchased by the town council with the intention of restoring the buildings as a museum. Unfortunately, funds ran out following the restoration of Huntly House and the future of Acheson House was uncertain.

In 1935, the Marquess of Bute bought the property and commissioned architects Neil and Hurd to restore the building. It was used as the premises of the Scottish Craft Centre for many years until 1991, after which its future was again uncertain. It is currently used as offices by Edinburgh World Heritage.

## 14. The Canongate Tolbooth

The Canongate Tolbooth is a landmark feature on the Royal Mile and one of the most distinctive and oldest buildings on the Canongate.

It dates from 1591 and is a rare survivor of sixteenth-century municipal architecture – the Old Tolbooth of Edinburgh obstructed the front of St Giles and was swept away in 1817. The Canongate Tolbooth was the administrative hub of the Canongate when it was an independent burgh, serving as the centre of local administration and justice with a courthouse, jail and council chambers.

It overflows with architectural detailing – turrets and gun loops to the street, a forestair in the angle of the tower and an oversized scrolled wrought-iron clock, which is a later addition of 1820 (it was repaired in 1884 and this date is inscribed on the clock). It is embellished by a large metal war memorial on the ground floor and a carved stone panel at first-floor level with the arms of the Canongate: a stag's head and Latin inscription 'SIC ITUR AD ASTRA 1128' (Thus is the way to the stars).

During the 1600s, many captured Covenanters were held in the tolbooth. In 1879, City Architect Robert Morham restored and remodelled the exterior. It now functions as The People's Story Museum, which tells the story of the lives of local people.

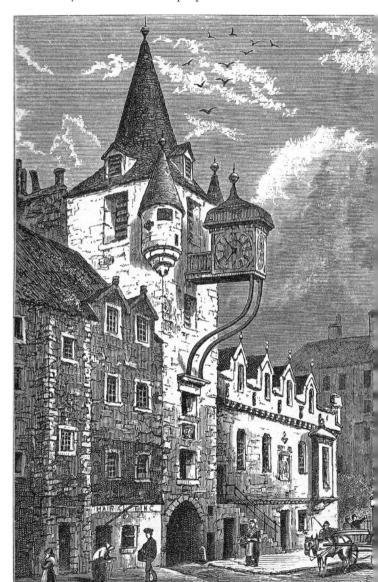

Canongate Tolbooth.

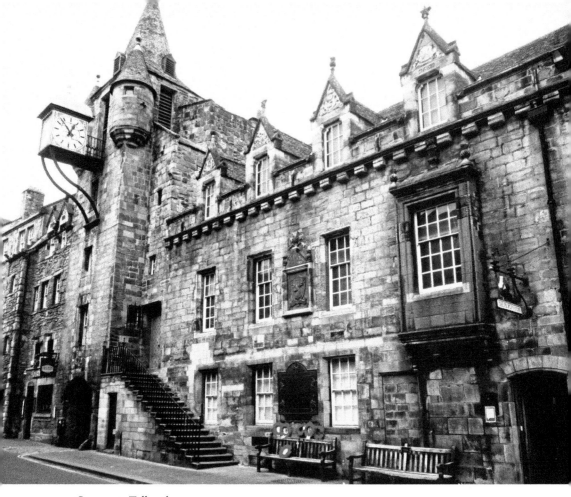

Canongate Tolbooth.

## 15. Whitehorse Close, Canongate

Whitehorse Close at the foot of the Canongate, with its idiosyncratic mix of crowstepped gables, harling, projecting bays, forestairs and pantiled roofs, is among the most picturesque of the Old Town closes.

The close has its origins in the early seventeenth century when it was built with houses, stables and the White Horse Inn on the site of the Holyrood Palace Royal Mews. The inn was the terminus of one of the first regular stagecoaches to London – a journey that took thirteen days (Scotland Yard was the London terminus for the coaches from Edinburgh). The name of the close is said to derive from a favourite horse of Mary, Queen of Scots, which was stabled at the Royal Mews.

In 1745, the close was the headquarters of the Jacobite army. It was also the home of William Dick (1793–1866), who founded the city's Royal Dick Veterinary College.

In 1889, the buildings were restored and converted into fifteen houses. By the 1960s, they were much in need of repair and upgrading. The extensive restoration and reconstruction work carried out by Frank Mears and Partners in 1964–65 was an example of the renewal of a historically important group of buildings that had deteriorated into a slum. It is often

criticised as representing over-restoration and architectural fakery. However, Mears' reconstruction accentuated the historic character of the close and created what is possibly one of the most charming corners of the Royal Mile.

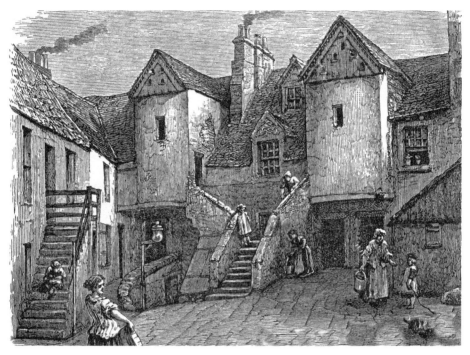

*Above*: Whitehorse Close.

*Below*: Whitehorse Close.

## 16. Holyrood Abbey

Legend has it that King David I was knocked from his horse by a stag while hunting on a holy day. The stag then tried to kill the king but, although wounded, he managed to grasp a cross that had miraculously appeared between the stag's antlers, at which point the animal retreated. That night St Andrew instructed the king in a dream to found the abbey in 'honour of the Holy Rood, and of St Mary the Virgin, and of all the Saints'.

The abbey was founded in 1128 and was the base of Augustinian monks who were granted the right by a charter of King David I to form a new burgh between the abbey and the Netherbow – the Canongate. The Scottish kings made the abbey their main residence when they were visiting the area until James IV started to build a palace.

The original abbey was rebuilt between 1195 and 1230 as a substantial building of great importance and splendour consisting of a choir, transept and an aisled nave. It has been witness to some of the most dramatic moments in Scottish history. It was repeatedly burned by English armies and suffered further damage in 1559, during the Reformation. After the Reformation, the nave was used as a parish church. However, in 1570 the choir and transept were in such poor condition that they were demolished.

The abbey was remodelled in 1633 for the coronation of Charles I and in 1687 it was converted into a Roman Catholic Chapel Royal. However, in 1688, it was sacked by the Edinburgh mob following the Glorious Revolution. In 1758, a heavy stone roof was added, which collapsed on the 2 December 1768, crushing the building beneath its weight and leaving the abbey as it currently stands – a roofless ruin of which only the nave remains. It is still one of the best examples of early medieval architectural work in Britain

Holyrood Abbey.

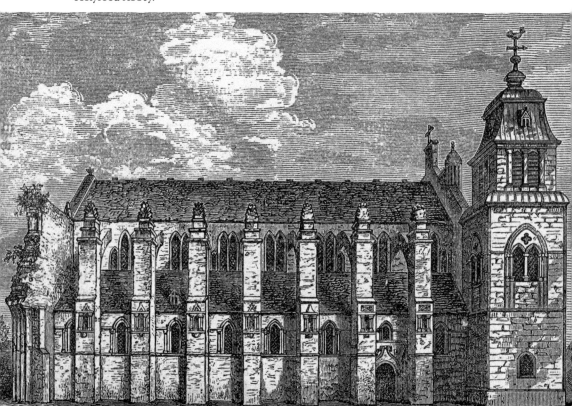

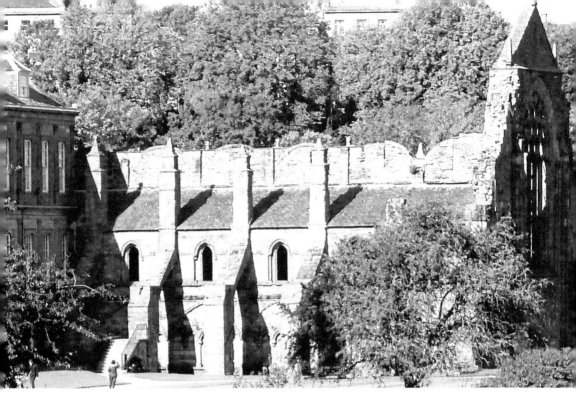

Holyrood Abbey.

and provides an indication of how elaborate the structure must have been. It is the last resting place of a number of Scottish kings.

The Holyrood Abbey Sanctuary for debtors was established in the twelfth century, under a charter granted by King David I. The ancient right of sanctuary within the grounds of Holyrood has never been repealed; however, the need for a debtors' sanctuary ended in 1880 when imprisonment for debt was abolished.

## 17. The Palace of Holyroodhouse

A house of many memories. Great people of yore, kings and queens, buffoons and grave ambassadors, played their stately farce for centuries in Holyrood. Wars have been plotted, dancing has lasted deep into the night, murder has been done in its chambers.

*Edinburgh: Picturesque Notes, R. L. Stevenson, 1879*

The Palace of Holyroodhouse developed from a royal guest house that was part of Holyrood Abbey. It was transformed into a royal palace at the start of the sixteenth century during the reign of James IV. Additions were made between 1528 and 1536 by his son King James V (1512–42), who is said to have 'built a fair palace, with three towers, in the Abbey of Hoylroodhouse'. The palace was damaged during English invasions, first by the Earl of Hertford in 1544, and again in 1650 during its occupation by Cromwell's troops.

The present palace largely dates from a reconstruction in 1671, when it was rebuilt in the French Chateau style by architect Sir William Bruce (1630–1710) and builder Robert Mylne (1633–1710) for the Restoration of Charles II.

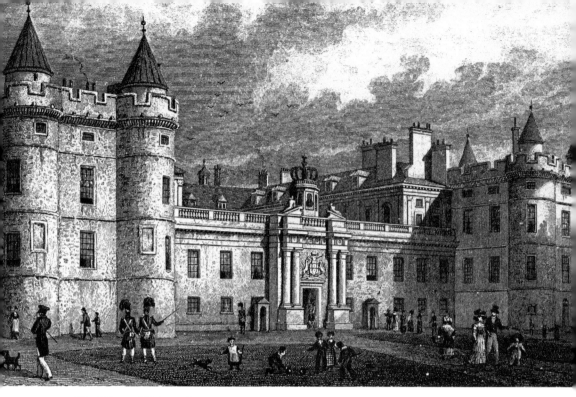

The Palace of Holyroodhouse.

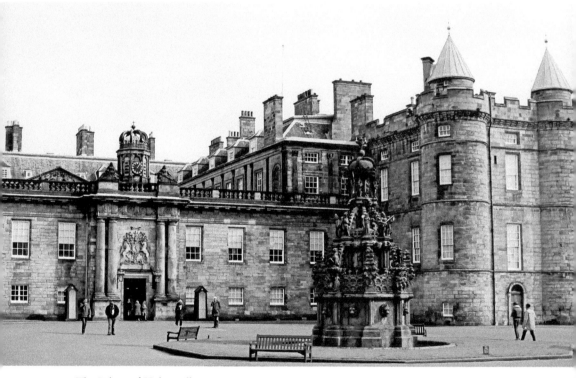

The Palace of Holyroodhouse.

The palace is the formal Scottish residence of the queen during state visits to Edinburgh.

The large and ornate fountain at the centre of the palace forecourt was erected as part of work to the palace grounds in the 1850s. It is a replica of a fountain at Linlithgow Palace, which dates to 1628. It was carved by John Thomas, a well-known sculptor of the time. The intricate carvings depict events from the history of the Scottish royal family and aristocratic pastimes, such as falconry and music.

## 18. The Scottish Parliament

The Holyrood North Site in the Old Town was one of the largest regeneration projects in Edinburgh in recent years, amounting to over 5 hectares of development land. It resulted from the closure and demolition of a Scottish and Newcastle Brewery. It provided numerous infill opportunities and the site for the Scottish Parliament building.

The result of the Scottish Devolution Referendum on 11 September 1997 approved the establishment of a directly elected Scottish legislature. On 1 July 1999, 292 years after the Treaty of Union, legislative powers were transferred from Westminster to the new Scottish Parliament.

A number of locations were considered for the parliament building and the site at the east end of the Canongate, which was occupied by the Scottish and Newcastle Brewery, was selected for the new custom-built building. An international architectural competition was announced and in 1998, after a lengthy consultation, the proposal by the Spanish architect Enric Miralles was selected as the winning design. Work on the development started in June 1999.

Miralles' original concept was inspired by elements of Scottish heritage and culture – upturned fishing boats, crow-stepped gables and features based on Sir Henry Raeburn's painting *Skater on Duddingston Loch*.

The extravagant modernism and complex abstract design were controversial from the beginning, and the aesthetic qualities of the new building have divided opinion. It has been given a number of prestigious architectural awards; however, it stands in stark contrast to the surrounding historic buildings in what is one of the most historic parts of the city. It has undeniably been a talking point, generating debate about design quality in a changing city.

The Scottish Parliament.

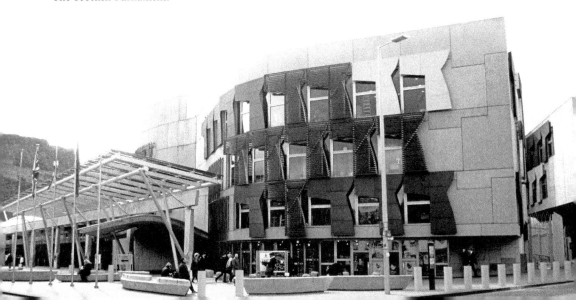

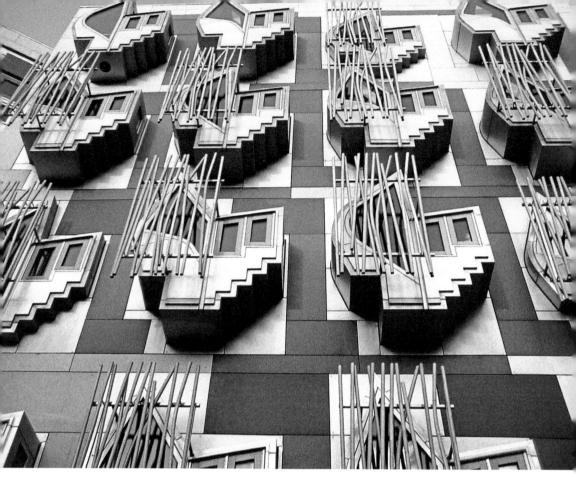

The Scottish Parliament window details.

Controversy also surrounded the construction phase with completion of the building delayed by around three years and the costs escalating from an original estimate of up to £40 million to a final bill of over £400 million.

Miralles died in the year 2000 before the completion of the building, which was opened by the Queen on 9 October 2004.

## 19. Bank of Scotland, North Bank Street

The Bank of Scotland building is an imposing baroque structure in a prestigious location looking down over the New Town from the Mound with a central copper-clad dome, wings extending to either side terminating in towers and pavilions, all sitting on a massive masonry plinth. Its mass is softened to some degree by a proliferation of decoration and statues. Framed views of the main entrance and dome terminate the vista south along the axis of George IV Bridge.

Edinburgh for centuries had a long tradition as a reputable financial centre – a stronghold of cautious financial management. The Bank of Scotland was established by an Act of Parliament on 17 July 1695 and the bank opened for business in February 1696, a few years after the foundation of the Bank of England.

The Bank of Scotland.

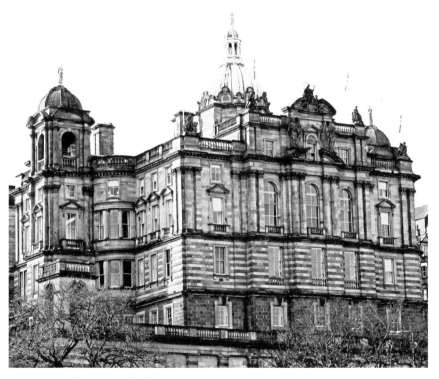

The Bank of Scotland – Market Street frontage.

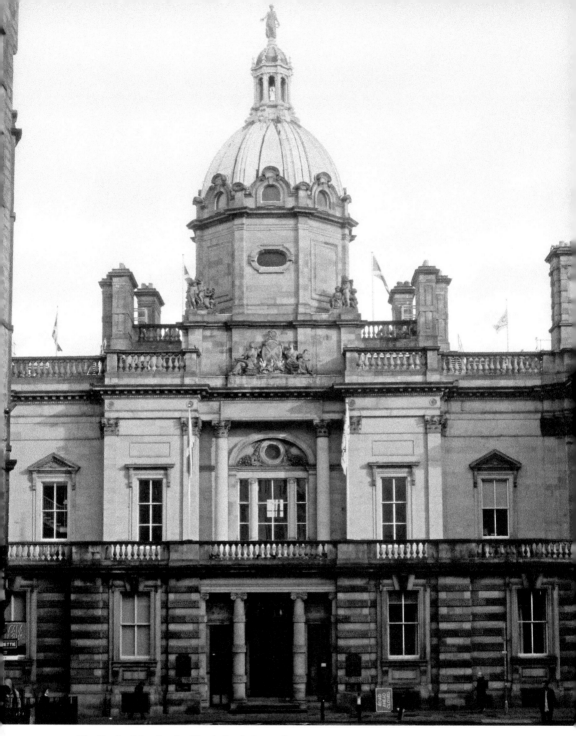

The Bank of Scotland – North Bank Street frontage.

The Bank's first headquarters were in Mylne Square, which was moved in 1700 to the east side of Parliament Close for a few years. For the next century, it had premises in Old Bank Close, which was demolished to make way for George IV Bridge. Bank Street was

formed in 1798 by the demolition of East and Middle Baxters' Closes and takes its name from the Bank of Scotland.

The new building for the bank was designed by Richard Crichton and Robert Reid, and was built between 1801–06 in a classical style. It was a fairly plain building and was not popular. It was grandly remodelled and enlarged in a rich Roman baroque style by David Bryce in 1864–70 – the original simple dome was replaced by a more elaborate example incorporating a lantern with a gilded statue of *Fame* on top. Part of the basement has been arranged as a museum, showing the history of the bank, including Bryce's presentation drawings.

## 2c. Charlotte Square

Restricted for centuries by its town walls, the Old Town grew, 'piled deep and massy, close and high', and, in 1767, a start was made to the architect James Craig's plan for a New Town, which was intended to relieve the serious overcrowding in Edinburgh's medieval core. A complete break was made with the old city, with a new site, a grid-iron plan, broad streets and formal architecture. This was followed by further planned Georgian developments up to the mid-nineteenth century, which form what has been described as 'the most extensive example of a Romantic Classical city in the world'.

Control over the appearance of the buildings was initially very relaxed – the only condition imposed was that Craig's plan should be followed, with continuous terraces set back from the pavement by a basement area. Despite the regular plots shown on the feuing plan, feus were sold in a variety of sizes and built as both town houses and tenement blocks of different scales and designs. The development was soon criticised for its irregularity, which conflicted with the order required by contemporary taste.

In 1791, the town council commissioned Robert Adam (1728–92) to complete detailed plans and elevations for Charlotte Square. This resulted in the first New Town development to use a consistent palace block design to create an elegantly symmetrical architectural unity across a number of individual properties.

The north side of Charlotte Square.

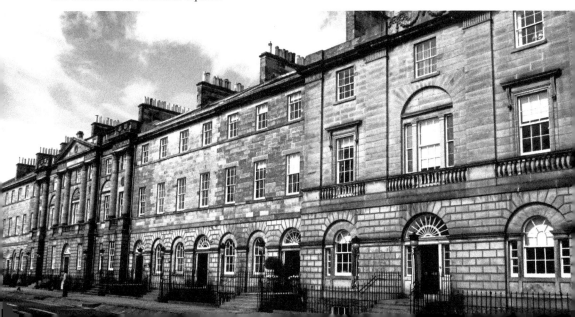

Adam died in 1792, and his original plans for parts of the square were amended following his death. However, the 100-metre-long north side of the square, which is the most elaborate, with its fine proportions and delicate detail, is fully Adam's and stands as an elegant tour de force of urban architecture.

Bute House at No. 6 is the official residence of the First Minister of Scotland and No. 7 is the National Trust for Scotland's Georgian House.

## 21. General Register House, Princes Street

By the mid-eighteenth century the need to provide accommodation for the public records of Scotland was widely recognised. Before 1662, they had been kept in the castle and from that date in 'two laigh rooms under the Inner Session House in a perishing condition'. A proper home for them had been proposed as early as 1722. In 1752, an act that led to the building of the Royal Exchange gave commissioners power to build a register house. Nothing came of these proposals until 1765, when representations to the government resulted in a grant of £12,000 being made for the construction of a 'proper repository'.

The Earl of Morton, the Lord Clerk Register, in association with the architect Robert Baldwin published a design in 1767 that consisted of a single-storey square building with a central dome; however, there was disagreement over the site. In 1769, the City supplied the ground opposite the north end of the newly completed North Bridge, where a significant public building was likely to encourage the development of James Craig's design for the New Town. It was a prestigious site facing along one of the principal street vistas in Edinburgh, standing at the meeting place of the Old and New Towns and terminating the first major route between them.

In September 1769, Robert Adam, along with his brother James, received the commission for the design of the new building. Adam's design of 1771 comprised a two-storey and basement building forming a rectangular quadrangle (61 metres by 47 metres) with towers projecting at each corner and halfway along each of the short sides, with the courtyard filled by a central hall under a domed rotunda surrounded by a ring of offices.

Work on the new building began in 1773; however, the scheme was reduced on financial grounds, and when the foundation stone was laid in 1774 only the south range, rotunda and the front half of the east and west ranges from the 1771 scheme were proposed for immediate construction. The structure was costly due to the need to make the building fireproof and provide stability for the storage of heavy record volumes and the money made available was insufficient even to allow construction of Adam's reduced design. Work was suspended at the end of 1778 and the roofless shell of the building stood empty as 'the most expensive pigeon house in Europe'. In 1785, a further government grant allowed work to recommence, with the building being ready for occupation by the end of 1788.

The building is two-storey on a raised basement forming a quadrangle with a domed circular reading room. It is finished in a polished cream sandstone ashlar with projecting taller single-bay pavilions at the corners and centre of the side elevations. The towers at each end of the façade are crowned with turrets and cupolas that project from the main wall-plane and are emphasised by Corinthian columns on their upper storeys. The ground

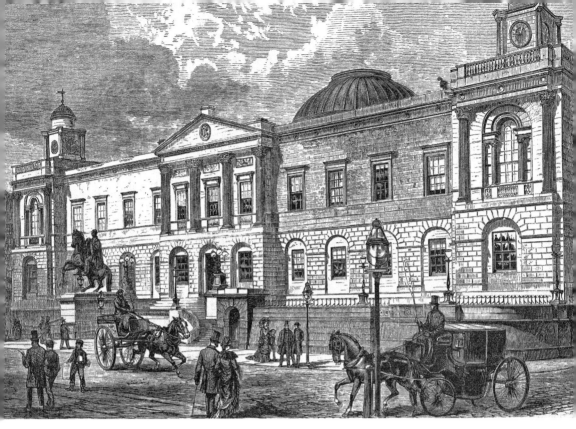

*Above*: General Register House.

*Below*: General Register House.

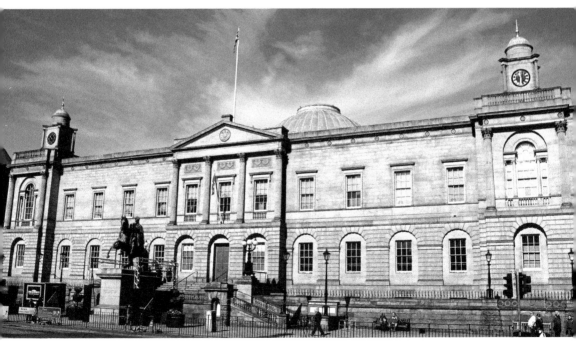

floor and pavilions are arcaded with windows set in arches. The main south elevation has rusticated stonework at the ground floor and a Corinthian centrepiece with a pediment bearing the roundel of the royal arms in patent stucco. The advanced pavilions have a pair of Corinthian columns at the first floor framing Venetian windows set in recessed arches. The interior was very simply finished except for the massive rotunda, which forms a space 21 metres high from floor to oculus and 15 metres in diameter.

Robert Adam died suddenly in 1792 before the building was complete. In 1822, it was enlarged to the dimension of Adam's 1771 design by the architect Robert Reid. In 1790, a clock was installed in the south-east tower and a wind-vane in the south-west. David Bryce pushed back the front area wall in 1849, in order to accommodate the bronze equestrian statue of the Duke of Wellington.

Register House was the first purpose built record office in Britain and is one of the oldest archive buildings still in continuous use in the world.

## 22. The Sir Walter Scott Monument, Princes Street

The fantastically ornate Sir Walter Scott Monument is the most prominent landmark in central Edinburgh and the largest monument to any writer in the world. Sir Walter Scott (1771–1832) was an enormously popular novelist who invented the Gothic historical novel and created the idea of Scottish Romanticism. His Waverley novels excited critical acclaim around the world. He was a prominent society figure who rediscovered the hidden Royal Scottish Regalia in Edinburgh Castle and orchestrated the visit by King George IV to Scotland in 1822 – the first British monarch to visit Scotland since Charles II in 1650 – for which he persuaded the king and dignitaries to wear the previously banned tartan.

The monument is made from Binny sandstone from West Lothian, designed in Gothic style with four arched buttresses supporting a central tower. It stands just over 61 metres high with foundations that plunge around 16 metres to stand on solid rock. It took six years to build and has 287 spiral steps to the top. Within niches on the ornate facade are sixty-four character statues from Scott's novels, carved by many well-known sculptors. On the first level there is a museum room with large stained-glass panels by James Ballantine showing emblems of St Andrew and St Giles, fine decorative carved oak and gilded portrait heads of Scottish historical characters.

Following Scott's death in 1832, funds were raised by public subscription to build a suitable memorial. In 1838, a competition was arranged for a design for the monument. The final winning design was by George Meikle Kemp (1795–844). He was a carpenter from Midlothian who had drawn Gothic architecture since his youth, was much inspired by Melrose Abbey, had been employed in the office of the Edinburgh architect William Burn and won the design competition over many established architects. Kemp drowned in the Union Canal on 6 March 1844 before the monument was finished and the final works were supervised by his brother-in-law, William Bonnar.

The foundation stone was laid on 15 August 1840 and the inauguration ceremony was on the same date (Scott's birthday) in 1846. Both occasions were marked with much pomp and ceremony – processions of a mounted military band; Masonic lodges; town councillors and magistrates of Edinburgh, Canongate, Leith and Portsburgh.

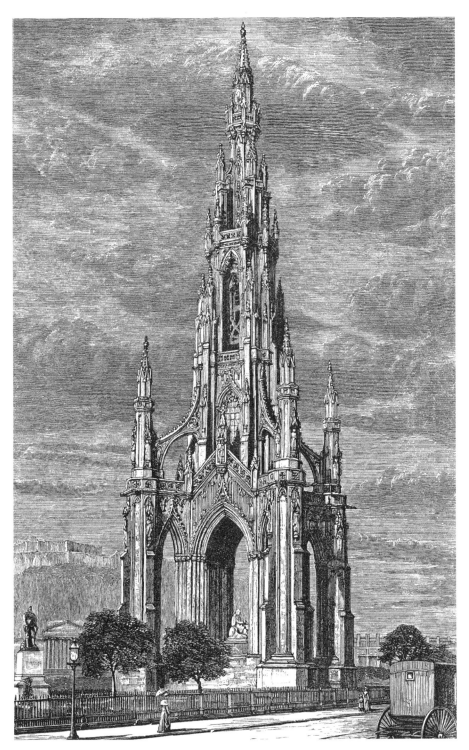

The Sir Walter Scott Monument.

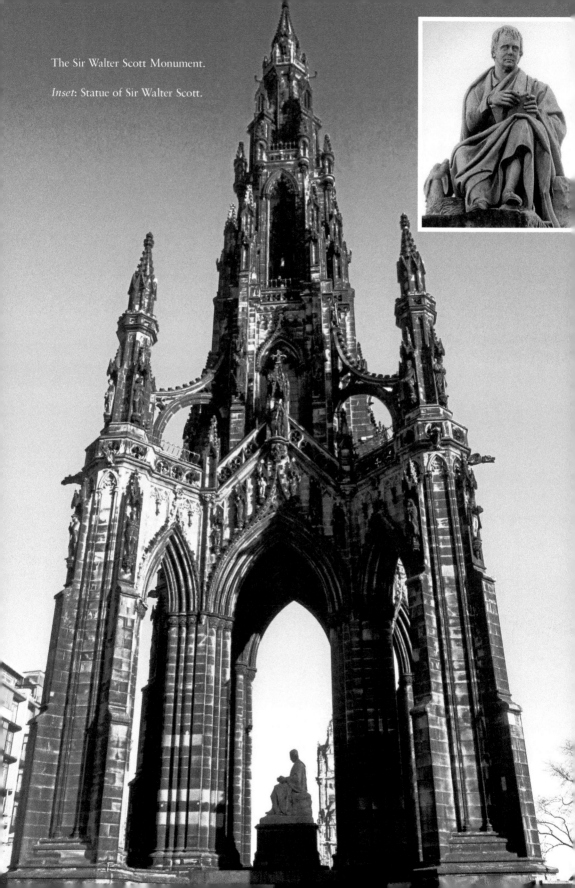

The Sir Walter Scott Monument.

*Inset*: Statue of Sir Walter Scott.

Sir John Steell (1804-91) was the sculptor of the Italian Carrara double life-size marble statue of Scott with his deerhound, Maida, on the central platform. A bronze copy of the Scott statue was bought by expatriate Scots in America and unveiled in 1872 in New York's Central Park.

In 1997–98, a comprehensive restoration of the monument was undertaken; stone from the specially reopened Binny Quarry was used to replace deteriorated masonry. The original stone, blackened by a century of smoke in 'Auld Reekie', was not cleaned as the removal of the grime would have damaged the stone.

## 23. Jenner's Department Store, Princes Street

Jenner's, the Harrods of Edinburgh, began life in 1838 when Charles Kennington and Charles Jenner were sacked from their jobs as Edinburgh drapers for attending the Musselburgh races rather than turn up for work. They promptly purchased the lease on a converted town house on the corner of Princes Street and South St David Street, and started their own drapers specialising in ladies' fashion and fancy goods. The name changed from Kennington & Jenner to Jenner's in 1868. On 26 November 1892, disaster struck when the original store burnt to the ground.

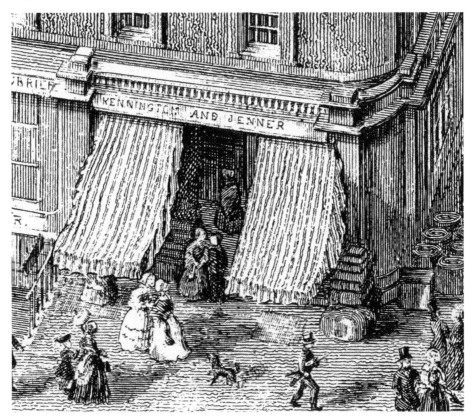

The original Kennington and Jenner shop.

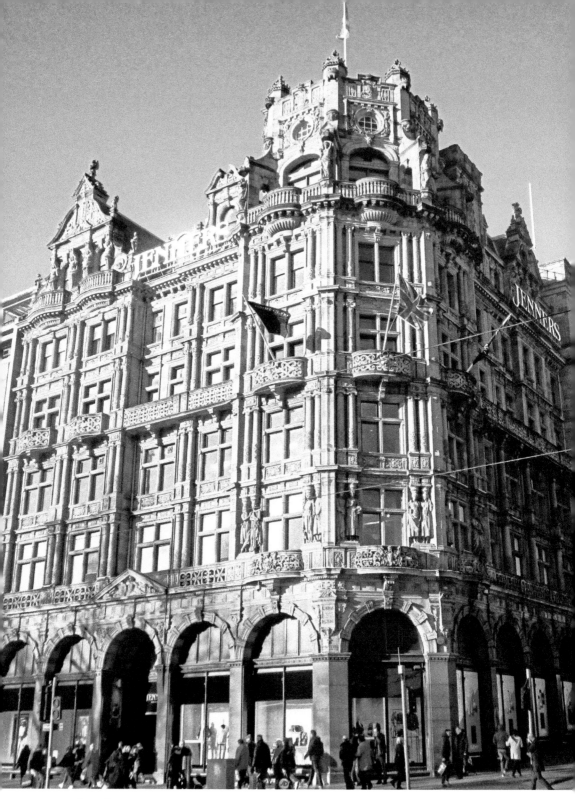

Jenner's.

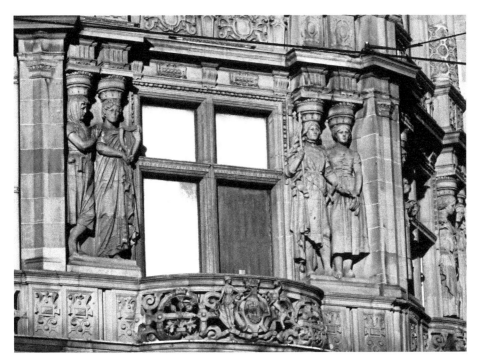

Jenner's – caryatid detail.

The new building was designed by William Hamilton Beattie, based on Oxford's Bodleian Library and opened on 8 March 1895. It was one of the largest department stores in Britain when it opened and until 2005 it was the oldest surviving independent department store in the world.

The massive six-storey building with its opulent, richly carved facade forms an impressive landmark at the corner of Princes Street and South St David Street. The splayed corner rises into an ornate richly decorated octagonal tower. The sculpted female figures (caryatids) at the first and fifth floor levels were intended 'to show symbolically that women are the support of the house'.

## 24. The Café Royal

Pubs have been the main focus of conviviality in Edinburgh for centuries and have played an indispensable part in the life of the city. It was the teeming nature of life in eighteenth-century Edinburgh that elevated the Old Town's taverns to a critical role in the city's social life and there was 'no superabundance of sobriety in the town' – in 1740, there were no fewer than 240 premises with drink licences in the Old Town. The early Edinburgh taverns were 'in courts and closes away from the public thoroughfare and often presented narrow and stifling accommodation'. They had a 'coarse and darksome snugness which was courted by their worshippers'.

These earlier basic taverns were swept away during the period 1880–1910, which is generally recognised as the golden age of pub design. These new pubs were ornamented

with an abundance of spectacular decoration to attract customers into their sparkling interiors.

The Café Royal is Edinburgh's best and most celebrated pub from this period. It is as splendid today as it was in the nineteenth century and its lavish interior reflects the heyday of the age of the most opulent Victorian pubs. Dating from 1861, it was originally built as a gas and sanitary ware showroom, became a hotel and was fitted out as a pub in 1901.

The exterior is in an exuberant French style with intricate glazing, heavily moulded console brackets, a deeply set curly pediment on the corner entrance to the Oyster Bar and a steep mansard roof, which is noted as the first of its kind in Edinburgh.

The quality of the exterior is echoed in the lavishly decorated interior. The main Circle Bar has superb woodwork, a panelled dado, a white-marble floor, a frieze decorated with ornate foliage motifs, a magnificent compartmented ceiling with hanging bosses at the intersections, a marble fireplace with an intricate overmantel, leather upholstered horseshoe seating areas and six Doulton tiled murals depicting famous inventors.

The Oyster Bar is separated from the Circle Bar by an arcaded and columned walnut screen with engraved mirror panels. The Oyster Bar retains its original red-marble counter and tiled panels on the bar front. It has been described as 'one of the grandest and also the most intimate of dining rooms in Britain'. There are another three tiled murals in the Oyster Bar and eight spectacular stained-glass windows depicting British sports – bowls, tennis, archery, deerstalking, hunting, fishing, rugby and cricket.

The Café Royal came under threat in the late 1960s, when it was proposed for demolition for the expansion of a shop at the east end of Princes Street. The massive public campaign against the redevelopment of this much-cherished Edinburgh pub resulted in the building being listed in 1970 and its future secured for the enjoyment of generations to come.

The Café Royal.

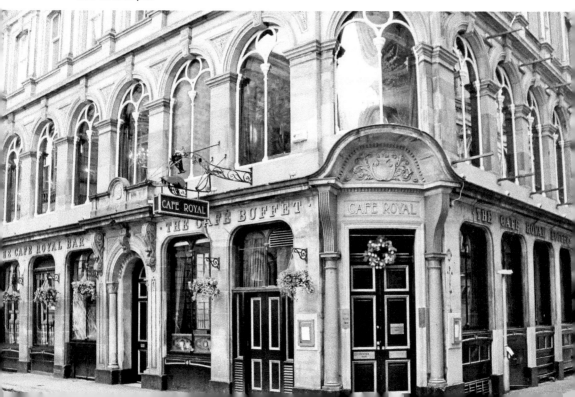

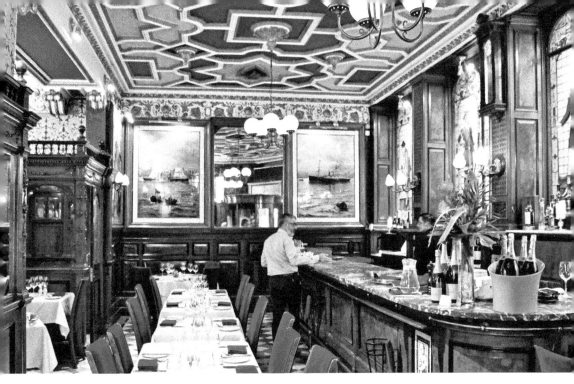

The Café Royal Oyster Bar.

## 25. The New Club, Princes Street

By the latter part of the nineteenth century many of the original small-scale Georgian domestic buildings on Princes Street had been replaced or radically adapted to accommodate the increasingly commercial nature of the street. These new buildings tended to be of a larger scale than their predecessors and were more ornate than the austere Georgian buildings they replaced. While the unified appearance of the street was lost, many of these new buildings were of significant architectural merit.

The Civic Survey and Plan for the City and Royal Burgh of Edinburgh (the Abercrombie Plan) was published on 1 January 1949. The plan included a number of radical proposals including the rebuilding of Princes Street, under which a second road was planned. It also criticised the laissez-faire development of the Victorian and Edwardian periods that had produced a lack of cohesion in the street. The scheme proposed by Abercrombie prescribed complete redevelopment of the street, within an overall framework for height and massing to restore visual cohesion.

This theme was controversially taken up by the Princes Street Panel's Report in the 1960s, again with the intention of overcoming the contemporary criticisms of Princes Street, which were centred on the lack of consistency between the various buildings. The idea was to restore the uniformity of the original Georgian development, which had been lost to later Victorian redevelopment. The report recommended that Princes Street should be comprehensively redeveloped. A unified design was to be achieved by rebuilding the street with new modern structures from end to end, with strict controls over height, materials, floor levels, frontage widths and the modelling of elevations.

A standard section incorporating an elevated pedestrian walkway with shops at first-floor level was also devised with the ultimate intention of creating a continuous high-level second street. A number of sites were redeveloped in line with the panel formula in the 1960s. However, by the 1970s, ideas regarding architecture and planning had changed. It had become clear that the Princes Street panel's recommendations paid inadequate attention to the architectural merits of older buildings along Princes Street and its recommendations were abandoned in 1982.

The reaction against Victorian architecture, and the sad loss of many fine buildings of the period, was symptomatic of the 1950s and 1960s – a time when progress and modernism was being widely embraced.

The department store for British Home Stores was the first building to adopt the panel's recommendations. The Category 'A' listed New Club by Alan Reiach, Eric Hall & Partners, dates from 1969 and is recognised as the best building incorporating the panel's requirements. Its construction involved the demolition of the original New Club building, which dated from 1837. The old New Club's immediate neighbour, the Life Association of Scotland building, which dated from 1858, was also a victim of the panel's principles.

The New Club.

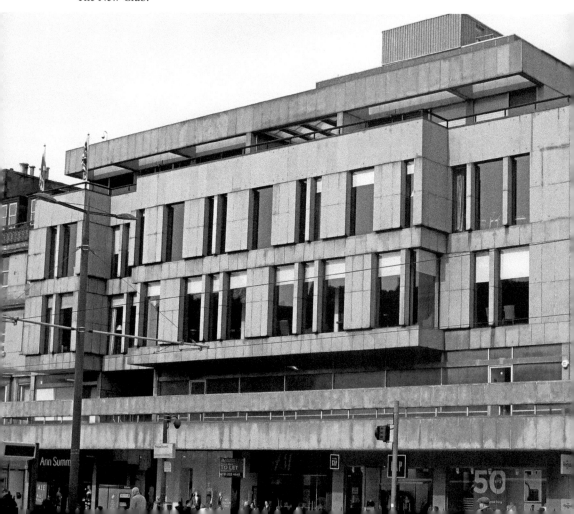

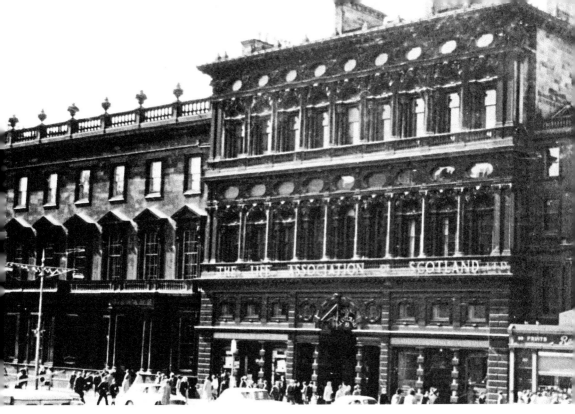

The original New Club and the Life Association of Scotland Building.

## 26. Royal Scottish Academy, Princes Street

The Royal Scottish Academy was designed in 1822–26 by William Playfair (1789–1857), Edinburgh's leading neoclassical architect of the time, for the Board of Manufactures and Fisheries to house the Royal Society, the Institution for the Encouragement of the Fine Arts, and the museum of the Society of Antiquaries. Its construction on the Mound, which was built up from millions of cartloads of earth and rubbish excavated during the building of the New Town, required driving 2,000 piles into the ground to stabilise the foundations – in 1898 and 1909–11 parts of the building had to be rebuilt when the pile foundations partially failed.

William Playfair's original building was rather austere and, between 1831 and 1836, Playfair was given a second chance at the design – it was extended, doubling its length, and refaced in a more elaborate classical style. It is an elegant Greek Doric temple, which, together with Playfair's Greek Ionic National Gallery of 1859, contributed to Edinburgh's reputation as the 'Athens of the North'. In 1911–12, the building was adapted to provide accommodation for the Royal Scottish Academy (previously housed in the National Gallery building).

The massive stone statue of Queen Victoria by John Steell on the roof of the building was erected in January 1844.

The Mound had previously been used as a 'receptacle for all things disreputable' and the 'resort of low class traders and entertainers', who set up roulette tables, shooting galleries, penny theatres, travelling menageries and coconut shies. A more permanent building was the Rotunda, built in 1823 to house Barker's Panorama showing magic lantern shows, which was demolished in 1850 to make way for the National Gallery.

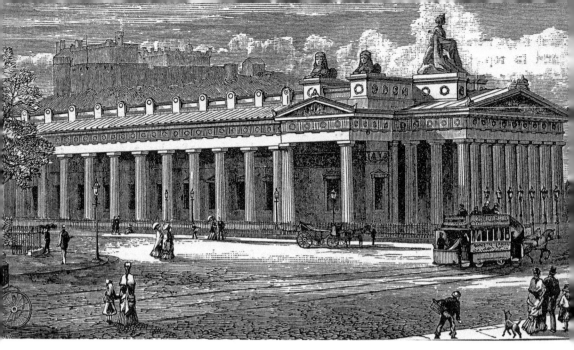

The Royal Institution.

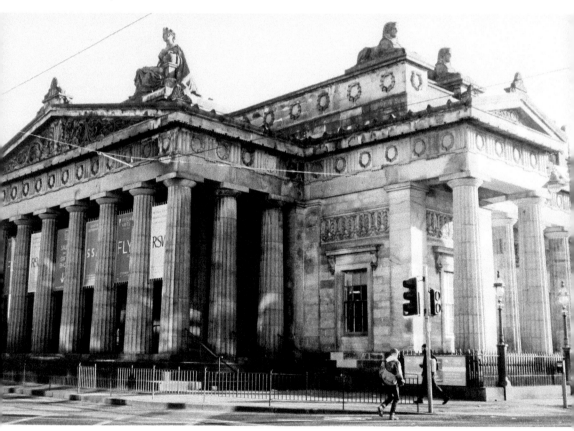

The Royal Scottish Academy.

## 27. Waverley Station

In the mid-1830s there were proposals for a railway line running through Princes Street Gardens to a new station at North Bridge. This was fervently opposed by residential owners of Princes Street properties, who had been involved in the expense of draining the Nor' Loch and creating the Gardens.

In 1836, an Act of Parliament approved the construction of the Edinburgh, Leith and Newhaven Railway, starting at the east end of Princes Street, with a rope-hauled tunnel under the New Town to Scotland Street, and branches off to Newhaven and Leith.

In 1842, the Edinburgh and Glasgow Railway opened Haymarket Station and pressure continued for a new terminus at North Bridge. In 1844, agreement was finally reached for a track, in a cutting flanked by high retaining walls, through Princes Street Gardens. In 1845, the long tunnel under Calton Hill was begun by the North British Railway Co.

Three railway companies had stations near one another in the valley at the east end of Princes Street – the North Bridge Station serving the North British Railway Co.'s line from Berwick-upon-Tweed, the Edinburgh and Glasgow Railway's General Station and the Edinburgh, Leith and Newhaven Railway Co.'s Canal Street Station. The name Waverley – from Sir Walter Scott's *Waverley* novels – was used as the collective name for the three stations from around 1854.

In 1868, the North British Railway Co. acquired all three stations, built a new station on the site and closed the tunnel link to Canal Street. The station was comprehensively rebuilt between 1892 and 1900 and was at the time the largest station in Britain, covering an area of over 25 acres (10 ha). The work involved was a complex engineering feat involving the rebuilding of North Bridge.

Waverley Station.

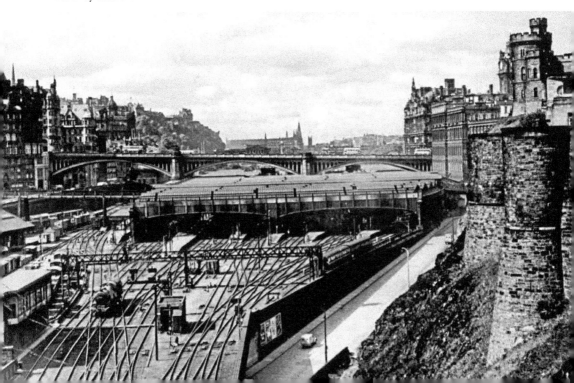

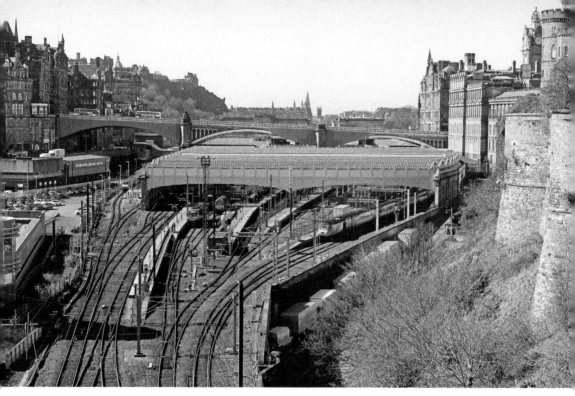

Waverley Station.

The station was designed to sit below a glass roof canopy to minimise its overall impact on Edinburgh's historic skyline. The glass roof was replaced between 2010 and 2012 by a new laminated glass system. It is one of the UK's best surviving Victorian railway stations and is still a busy transport hub for the city.

The new station resulted in the removal of the Old Orphan Hospital, Lady Glenorchy's Church, Trinity College Church, Trinity Hospital, the Fish and Vegetable Markets and the Old Physick Garden. The removal of Trinity College Church was particularly controversial and was subject to a condition that it should be re-erected at the expense of the railway company. The building was taken down and the numbered stones were stored on Calton Hill. However, many of the stones disappeared before they could be reused and only the choir and apse were eventually rebuilt on Chalmer's Close in 1872 – some of the numbered stones can still be seen in the walls.

## 28. The Balmoral Hotel, Princes Street

The massive Balmoral Hotel was opened in 1902 as the North British Railway Hotel to cater for the increased number of travellers arriving by train and is a major landmark at the east end of Princes Street. The architect, William Hamilton Beattie, was also responsible for the Jenner's building on Princes Street.

The clock on the 58-metre-high tower of the hotel is kept three minutes fast to give rail passengers an incentive to catch their trains (it is reset to the correct time for Edinburgh's Hogmanay). It became the Balmoral in 1991 after extensive renovation work, but many in Edinburgh still refer to it as the North British or NB.

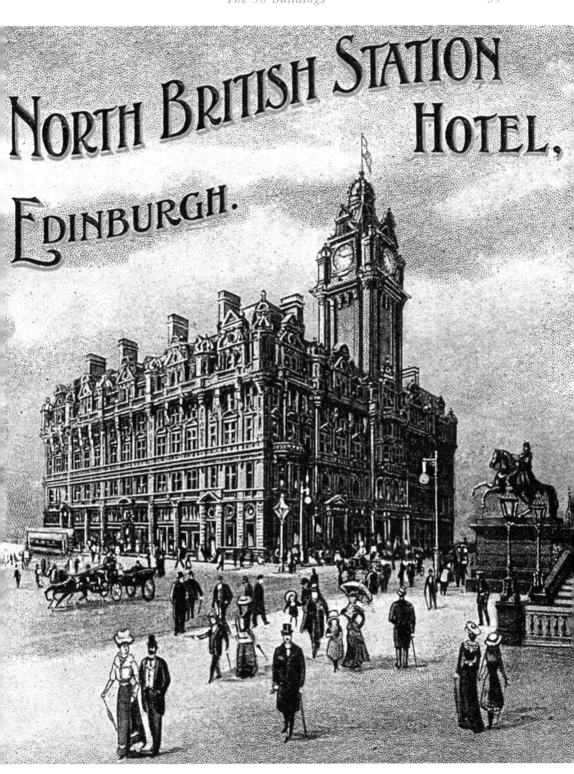

The North British Station Hotel.

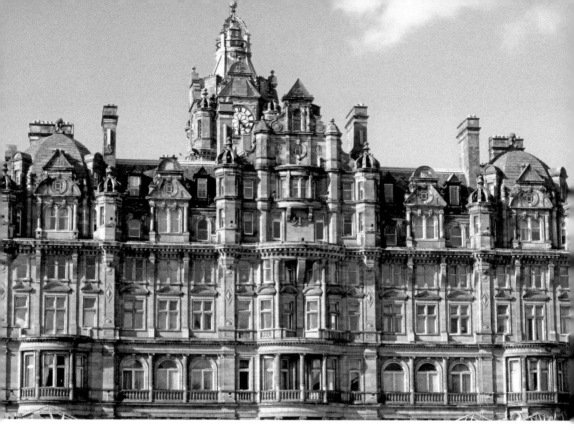

The Balmoral Hotel.

## 29. Former Royal High School, Regent Road

The former Royal High School building occupies a spectacular location on the southern slope of Calton Hill and is recognised as a masterpiece of Greek Revival architecture. The building was designed to link in with the monuments on Calton Hill, forming a kind of Scottish Acropolis, and made a key contribution to Edinburgh's status as the 'Athens of the North'.

The Edinburgh High School was originally founded in 1128 (making it the oldest school in Scotland) in association with Holyrood Abbey. From the sixteenth century, the school was located at the High School Yards on the South Side. By the early nineteenth century, it had outgrown the High School Yards location.

In 1825, the Calton Hill site was selected for the new building. The architect was Thomas Hamilton, a former pupil of the school's predecessor. Hamilton's monumental masterwork was based on Greek Doric temple designs – the Temple of Theseus in Athens. The building consists of a central pavilion with colonnades linking on both sides to two smaller pavilions, which masterfully exploits the picturesque potential of the site.

It was not an easy location to develop and the construction involved removing a large section of Calton Hill to create a level site. The building was completed in 1829, at a final cost of £34,000 – some £14,000 over the original budget. King George IV contributed £500 towards the costs and the school gained the 'Royal' appellation.

The school moved to Barnton in 1968 and the main hall in the building was converted into a debating chamber for the anticipated Scottish Assembly prior to the 1979

devolution referendum, which failed to provide enough support for a devolved assembly. Following the Scottish devolution referendum of 1997, the proposal to use the building as the home of the Scottish Parliament was abandoned in favour of a purpose-built new building in the Old Town.

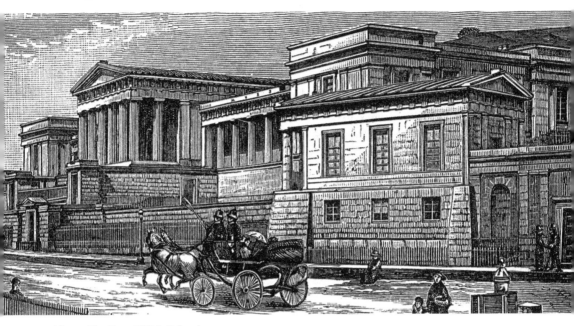

*Above*: The Royal High School.

*Below*: The former Royal High School.

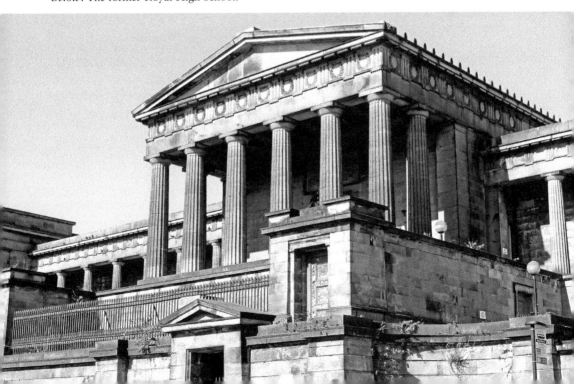

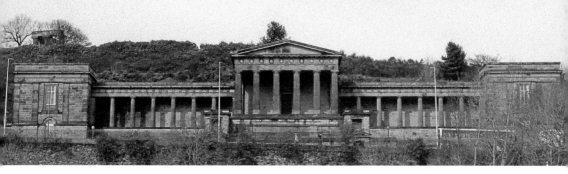

The former Royal High School.

There have been various proposals for the reuse of the building. However, at the time of writing, the future use of the building is still in doubt.

## 30. The National Monument, Calton Hill

The twelve massive columns of the unfinished National Monument on Calton Hill are known as 'Edinburgh's Folly' and 'Edinburgh's Disgrace', and are said to represent 'the pride and poverty of Scotland'. Although incomplete, the monument is central to Edinburgh's reputation as the 'Athens of the North'.

The plan for a National Monument, to commemorate Scottish servicemen who died in the Napoleonic Wars, was first discussed at a meeting of the Highland Society of Scotland in 1816. Supporters included Sir Walter Scott and Lord Elgin (who had removed sculpture from the Parthenon in Athens). Plans were considered for Triumphal Arches, and Archibald Elliot proposed a design for a circular building based on the Pantheon. However, it was finally decided that the monument should take the form of a temple structure based on the Parthenon. Charles Robert Cockerell, who was familiar with the Parthenon, was appointed architect and William Henry Playfair was appointed as his assistant. The plan was to set the building on a platform incorporating catacombs, where illustrious Scots would be laid to rest. The foundation stone was laid by George IV in 1822.

Work on the monument started in 1826 with some of the largest pieces of stone taken from Craigleith Quarry at Blackhall being used in its construction – twelve horses and seventy men were needed to move some of the larger stones up the hill. During the first phase of the work, over the period 1826–29, the twelve pillars cost £13,500. It was estimated that £42,000 was required for the work and despite generous subscriptions from many eminent people, including George IV, the Duke of Atholl and Sir Walter Scott, only £16,000 was raised. By 1829, funding was exhausted and the project was abandoned.

There have been many plans for the completion of the monument over the decades. However, it remains just as it did when the scaffolding came down in 1829.

Calton Hill includes an impressive collection of other monuments. The Nelson Monument consists of a 30-metre-high circular stone signal tower, looking a lot like a telescope. The circular Dugald Stewart Monument by William Henry Playfair was erected by public subscription to commemorate Stewart (1753–1828), who was Professor of Moral Philosophy at the University of Edinburgh. The John Playfair Monument is a square stone temple-like structure in a Greek Doric style, which commemorates John Playfair (1748–1819), Professor of Mathematics and Natural Philosophy at Edinburgh University and which was designed by his nephew W. H. Playfair.

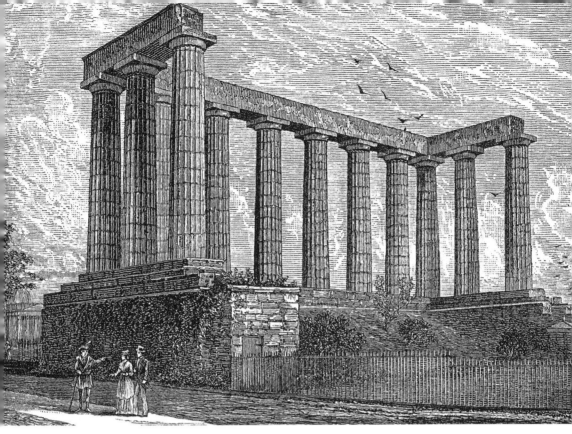

*Above*: The National Monument.

*Below*: The National Monument.

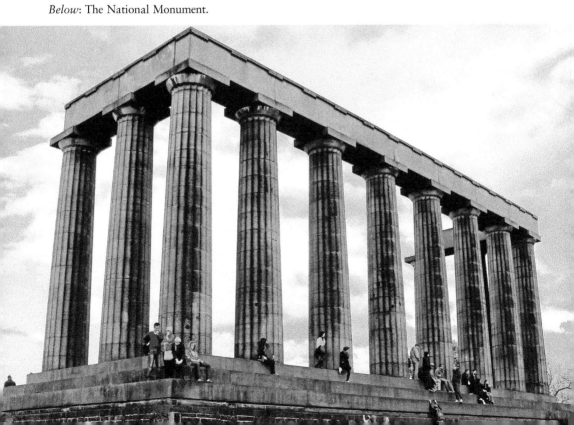

## 31. St Andrew's House, Regent Road

St Andrews House is widely recognised as one of the finest examples of interwar architecture in Scotland. The building is monumental – a superb fusion of classical and art deco – and occupies a dramatic hillside site. The architect was Thomas Tait (1882–1954), one of the most influential architects of the time, who was internationally renowned and is perhaps best known for his work on the Glasgow Empire Exhibition of 1936–37.

It was first occupied by civil servants on Monday 4 September 1939, the day after war was declared, and the formal opening ceremony by the king and queen was cancelled.

The frontage to Regent Road is particularly notable for the quality of its detailing with sculptures representing Architecture, Statecraft, Health, Agriculture, Fisheries and Education by Sir William Reid Dick (1879–1961). Tait intended the striking rear elevation to 'grow out of the landscape and appear part of it'.

The new building was on the site of the gloomy Calton Jail, which was described by one of its inmates as 'the poorhouse of all prisons with the cold chill of a grim fortress'.

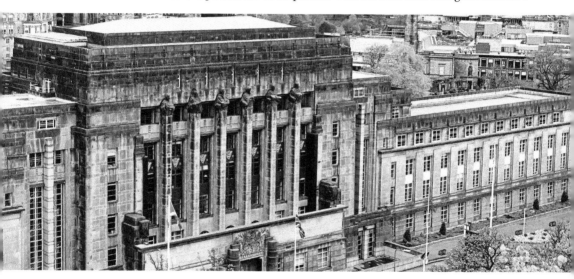

*Above*: St Andrew's House, Regent Road.

*Below*: St Andrew's House – the rear elevation.

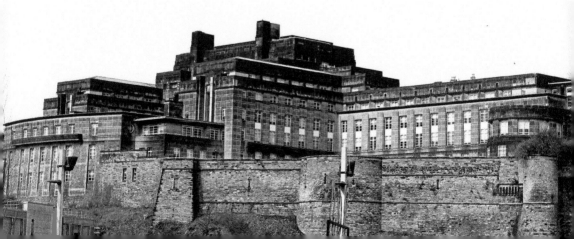

With some degree of irony, Arthur Woodburn (1890–1978), who was imprisoned in the jail as a politically motivated conscientious objector during the First World War, ended up occupying the most prestigious walnut-panelled art-deco rooms in St Andrew's House, from 1947 to 1950, as Secretary of State. The circular Governor's House is a lingering reminder of the old jail.

## 32. The Murphy House, Hart Street

The Murphy House was designed by local architect Richard Murphy as his own home and dates from 2014. Its striking geometric outline in glass, concrete and steel forms a stunningly modern termination to a short stretch of early nineteenth-century Georgian terraced houses on Hart Street in the New Town.

Richard Murphy has described the house as 'a quarter Soane, a quarter Scarpa, a quarter eco-house and a quarter Wallace and Gromit' – references to the Italian architect Carlo Scarpa, the Sir John Soane museum in London, the energy-saving technology and the host of quirky features, which include a hidden bath and moving walls .

The architect Richard Murphy and his Hart Street house.

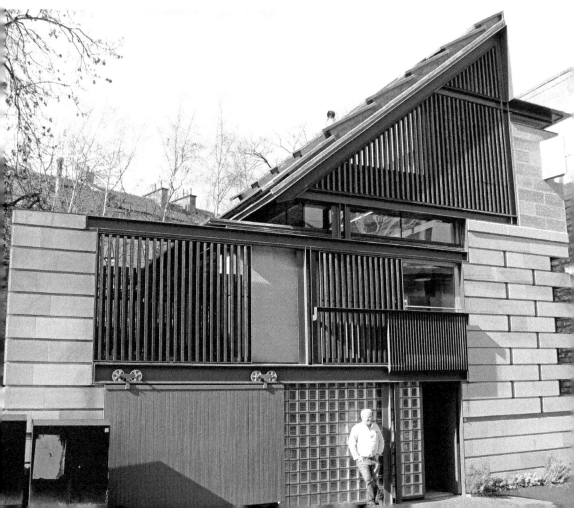

The evolution of such an imaginatively modern house on a site in the Georgian New Town was controversial. However, it was voted the House of the Year for 2016 by the Royal Institute of British Architects.

## 33. Well Court, Dean Village

Dean Village, which was formerly known as the Water of Leith Village, developed at a fording point on the Water of Leith. It was already a milling community in the twelfth century and by 1700 there were several mills and two large granaries. The importance of Dean Village as a traditional crossing point of the Water of Leith ended with the completion of Telford's Dean Bridge in 1832 and before the end of the nineteenth century the watermills were redundant. In the centre of the village there is still an eighteenth-century single-arched stone bridge that once carried the old coaching route from Edinburgh to Queensferry.

In the early 1880s, the site of Well Court was occupied by some neglected tenements, which were bought by Sir John Ritchie Findlay, the then proprietor of the *Scotsman* newspaper. Findlay was distressed by the poverty of his less fortunate neighbours and commissioned Sidney Mitchell to design a new development of social housing on the site as a philanthropic venture – it had the additional benefit of improving the view from the rear of Findlay's house at Rothesay Terrace. In 1896, Findlay was granted the freedom of city in recognition of his philanthropy.

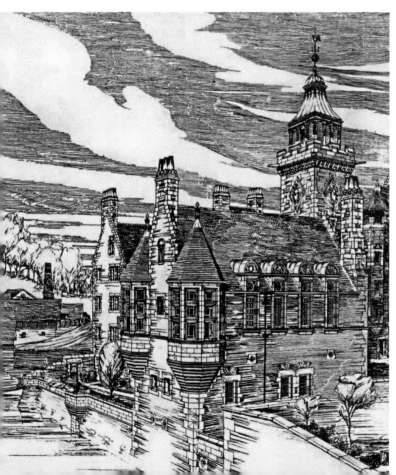

Well Court.

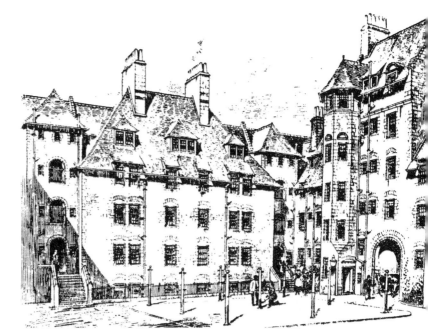

*Right*: Well Court
courtyard.

*Below*: Well Court.

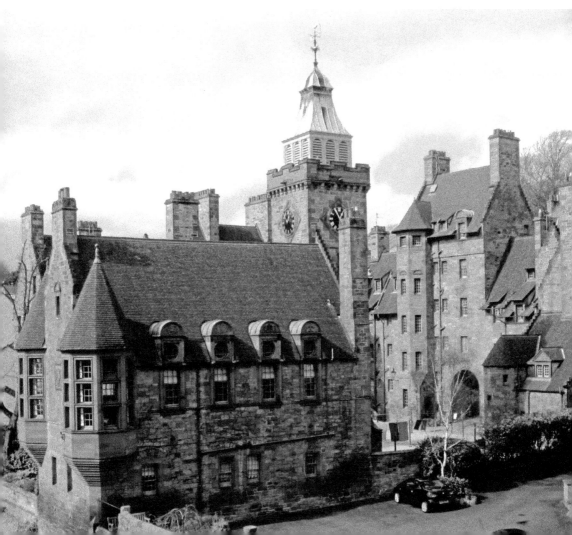

Well Court was built in 1883–85 and forms a quadrangle of small flats with a detached former social hall around a central courtyard. The design by Sidney Mitchell reflects the interest in traditional Scottish vernacular architecture at that period. The building is built in sandstone with red-sandstone dressings and a red tile roof. The small astragalled windows, crowstep gables, turrets and flamboyant roofscape are derived from Scottish Renaissance forms and contribute to Well Court's picturesque character. The former community hall, with its elaborate lead roof, gunloops, and corbelled battlements, is an important local landmark. The design of the five-storey clock tower is based on the Earl's Palace in Kirkwall.

In 2007, Edinburgh World Heritage and the owners of the building funded a major restoration of Well Court.

## 34. St Bernard's Well

According to tradition, St Bernard's Well was re-discovered by three Heriot's school boys while fishing in the Water of Leith in 1760. It takes its name from St Bernard of Clairvaux, the founder of the Cistercian Order. Legend has it that it was originally discovered by the Saint in the twelfth century.

In September 1760, the mineral spring was covered by a small wellhouse. 'Claudero' (James Wilson), the contemporary poet, composed a eulogy for the occasion: 'This water so healthful near Edinburgh doth rise which not only Bath but Moffat outvies. It cleans the intestines and an appetite gives, while morbfic matters it quite away drives.'

Chemical analysis revealed that the water was similar to the sulphur springs at Harrogate in Yorkshire. The mineral well soon became a popular resort for those afflicted by the fad for 'taking the waters'. By 1764, the well was so great an attraction that accommodation in the Stockbndge area was at a premium during the summer season. The well then resembled a Continental cafe with 'little tables where regulars chatted with friends'. It seems that habitual drinkers of the waters must have had cast-iron constitutions, for one later visitor likened the flavour of the water to 'the washings of foul gun barrels'.

In August 1788, the well was bought by Lord Gardenstone, who claimed he had derived great benefit from drinking the waters and, in 1789, the present construction, a circular Roman temple, was commissioned by him from the architect Alexander Naismith. The elegant architectural structure, in the form of a Doric rotunda, is inspired by the Temple of Vesta at Tivoli in Italy and encloses a marble statue of Hygieia, goddess of health.

In 1885, the well and grounds were purchased by the publishers Thomas Nelson & Sons. After restoration, it was left to the City of Edinburgh. The pump room was refurbished in lavish Victonan style. The interior was designed 'like a celestial vault sparkling with sequin like stars when sunlight strikes through the stained-glass windows'. The white-marble pedestal is inscribed *Bibendo Valebis* (By Drinking You Will Be Well).

Remarkable claims continued to be made for the well's medicinal properties, ranging from the value of a regular morning glass as a tonic for the system to a complete cure-all for rheumatism and arthritis. Aerated water from the well was even bottled and marketed for a short while. The well remained popular until its closure in 1940.

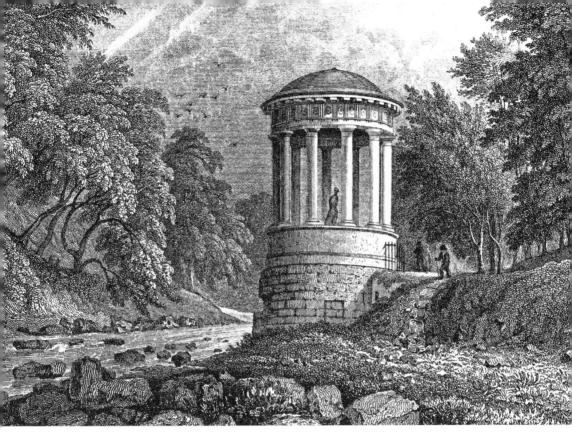

*Above*: St Bernard's Well.

*Right*: St Bernard's Well.

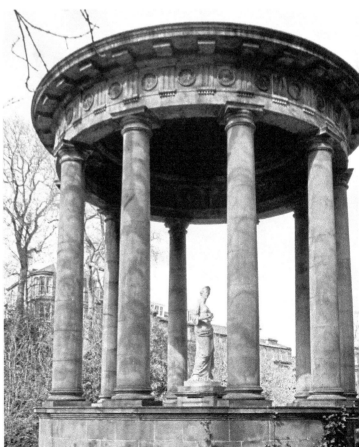

## 35. The Stockbridge Colonies

The 1867 Improvement Act was used to carry out large-scale slum clearance schemes in the Old Town. This included the construction of a number of institutional buildings, and the net effect was a reduction in the total, albeit defective, housing stock. Many Old Town's residents were displaced from their homes and already overcrowded houses were further subdivided.

In 1861, many builders in Edinburgh were locked out of work due to a dispute about working hours. This led to the formation of the Edinburgh Co-operative Building Co. Ltd, which was founded by seven Edinburgh stonemasons in July 1861. The intention of the company was to use their collective practical skills to build 'comfortable and respectable houses' for rent or sale at reasonable prices.

The first development by the company was at Glenogle Park (the Stockbridge Colonies). The foundation stone was laid on 23 October 1861 by the Revd Dr James Begg. The design of the houses, inspired by earlier developments – the Pilrig Model Dwellings (1852) and Rosebank Cottages (1857) – was distinctive, with smaller ground-floor houses (the low doors) entered on one side of the terrace, and the larger upper-floor houses (high doors) entered by an outside stair on the other side of the block. The terraced style of the Colonies allowed building costs to be kept low through shared foundations and roofs. The external stair access to the upper flats was also estimated to reduce building costs, save internal space and was easier to build than an internal stair.

The first houses at Stockbridge cost between £100 and £130, and a mortgage scheme was established to allow 'every facility for acquiring the Company's property'. The company specified that the houses at Stockbridge were to be 'substantially built with stone and lime and roofed with slate, and exclusive of chimney tops, not to exceed forty-six feet'. It also made a condition of purchase that it was 'unlawful to convert, or permit to be converted, any of the dwelling houses into sheebens or brothels or to have any cow house, pig house, or manufactory'.

The interior of the houses provided a standard of facilities that were exceptional in working-class housing of the period – each had a parlour and kitchen, an indoor toilet, a kitchen range, and gas lighting.

The type of housing became known as Colonies. It is suggested that the term derives from the fact that the developments were outside of the city when they were first built or that they were colonies in the sense of a community of similar people (artisans). The emblem of the Edinburgh Co-operative Building Co. was a beehive and it is also suggested that the term derives from workers acting together for the common good, like bees.

The Edinburgh Co-operative Building Co. flourished in the 1860s and by 1872 the company employed some 250 workmen and had built nearly 1,000 homes. However, by the mid-1870s, the cost of land was becoming expensive and the scale of building was cut back. In 1902, one of the directors of the company noted that the 'golden times (for the company) have passed'.

The Colonies provided high-quality homes based on the principles of mutuality and participation. They are a monument to the co-operative housing movement and remain a popular choice for present-day home ownership.

*Right*: The Stockbridge
Colonies.

*Below*: The Stockbridge
Colonies.

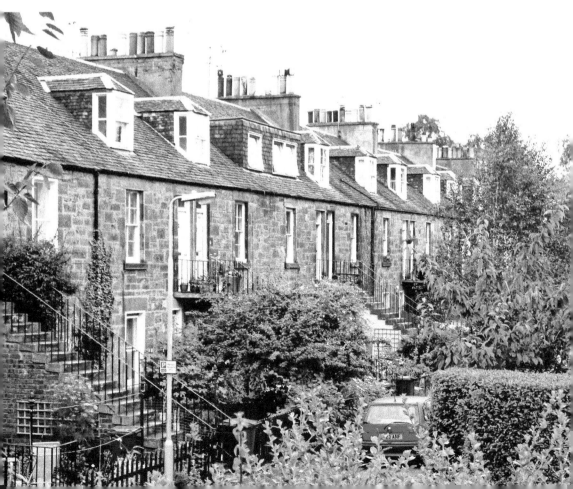

## 36. The Temperate Palm House, Royal Botanic Garden

The Temperate Palm House at the Royal Botanic Garden dates from 1858 and was designed by Robert Matheson. With its giant round-headed windows, Doric pilasters, slender cast-iron columns, and soaring iron and convex glass dome it is a stunning example of Victorian architecture and engineering. At an imposing 22 metres in height, it is the tallest glasshouse in Britain. The Palm House was built at the peak of the Victorian mania for the collection of exotic plants and Parliament provided a grant of £6,000 for the construction of the building.

The Temperate Palm House.

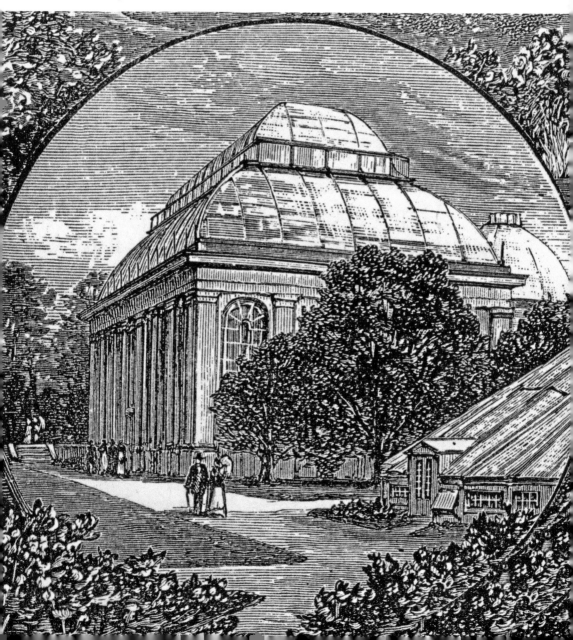

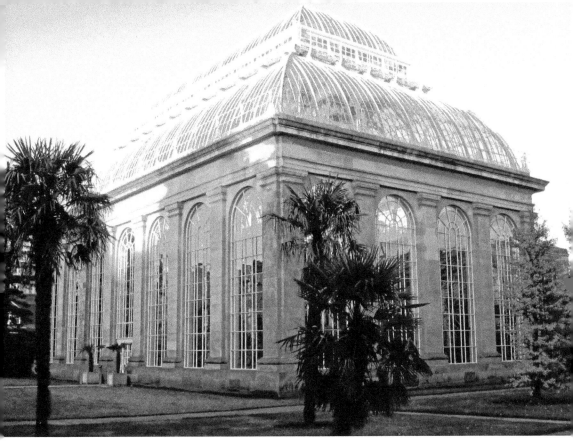

The Temperate Palm House.

The Royal Botanic Garden began as a physic garden growing medicinal plants on a small site near Holyrood Palace in 1670. By 1676, it occupied an area where the north-east corner of Waverley Station now stands and was known as the Town Garden. The Royal Botanic Garden received a Royal Warrant as early as 1699, and in 1763 moved again to Leith Walk in the grounds of what was the old Trinity Hospital.

Constantly outgrowing its various locations, it finally moved to a new site on the east side of Inverleith House between 1823 and 1824. The move from Leith Walk was carried out by William McNab, supervised by the Professor of Botany, Robert Graham, and involved the transplanting of some large specimen trees. In 1877, Inverleith House and its policies were added to the Botanic Garden site – the extension was opened in 1881. A wealth of plant material brought back by collectors established the Botanic Garden as a major centre for taxonomic research.

## 37. Nos 25–36 Castle Terrace and Nos 11–17 Cornwall Street, Edinburgh

It would be mad if it were not so large, so logical and so beautifully built.

*Buildings of Scotland, Edinburgh*

The Victorian expansion of the city resulted in the development of villa areas such as the Grange, which offered large detached houses in a suburban setting. High-quality tenements, such as those in Marchmont, were another feature of this period.

This residential development of picturesque street architecture, consisting of twelve tenements on a prominent corner site, was constructed from 1868–69 to designs by Sir James Gowans and is one of the finest examples in Edinburgh of the intricacy of High Victorian Gothic architecture. The main features of the group are the octagonal bay windows, the steeply sloping roofline, the castellated chimneys, and the profusion of elaborate stone decoration.

In October 1868, *The Builder* carried the following note on the development:

> The first instalment of the new buildings designed by Mr James Gowans, in his own peculiar style, is now completed, so far as the elevations are concerned. The peculiarity of the style consists in the ignoring of every known detail and the application of mouldings more suited for execution in wood than in stone, the profile only of which is generally presented to the spectator. The general effect produced by the number of gables, moulded chimneys, and statues breaking the skyline, is striking and picturesque. Mr Gowans deserves to be complimented on his pluck.

Sir James Gowans (1821–90) was a quarry developer, railway engineer, tramway pioneer, social reformer, building contractor, politician, Edinburgh's Lord Dean of Guild and an unconventional architect. He also organised Edinburgh's International Exhibition of 1886, for which he received a knighthood from Queen Victoria.

Gowans' Rockville, or, as it was variously known, the Pagoda, the Chinese House, Tottering Towers and Crazy Manor, was described as 'a building to delight every child who

Castle Terrace and Cornwall Street.

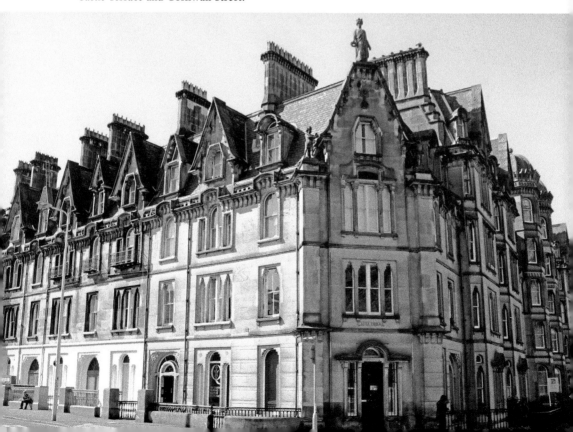

Rockville.

enjoys a fairy tale'. It stood at the corner of Napier Road and Spylaw Road in Edinburgh's Merchiston area and was built by Gowans in 1858 as his own home. The external walls were constructed in Gowans' checkerboard pattern of stone strapwork, which projected beyond the surface of a large-scale mosaic infill of coloured stones, giving a rich effect of lightness and sparkle. Rockville was demolished in 1966 and a block of flats constructed on the site. However, a hint of the romantic eccentricity of Rockville can still be seen in the surviving stone wall and gateposts.

## 38. Cables Wynd House, Kirkgate, Leith

By 1920, when Leith was amalgamated with Edinburgh, the building stock had deteriorated significantly and was even then in need of attention. The Great Depression of the 1930s, followed by the interruption of the Second World War and the austerity of the 1950s, meant that the 'modernisation' of Leith was delayed until the 1960s. When improvement came, the face of Leith was changed forever.

Major slum clearance projects of the 1960s targeted the crammed tenements, shops and small workshops along the old and historic streets in the heart of Leith. The Kirkgate, St Andrew Street, Tollbooth Wynd, Bridge Street and many more were replaced by large public housing schemes during the decade.

Cables Wynd House, or, as it is better known, 'the Banana Flats', was built between 1963 and 1965. It is a long ten-storey slab block and takes its soubriquet from the bend in the middle, which gives it the appearance of something that resembles a banana. It famously makes an appearance in Irvine Welsh's *Trainspotting*, as the childhood home of Simon 'Sick Boy' Williamson.

Cables Wynd House.

Inspired by the brutalist architectural style of Le Corbusier's Unité d'Habitation at Marseille, France, Cables Wynd House is considered an important surviving example of post-war multistorey blocks representing a time of major social change.

At the time of writing, Cables Wynd House was rather controversially listed, along with the slightly later multistorey Linksview House, at Category 'A' – signifying a building of national importance.

## 39. National Library of Scotland, George IV Bridge

The Faculty of Advocates library opened in 1689 and from 1710 functioned as the national library with the right to claim a copy of any British publication. In 1925, the faculty presented its collection to the nation and, in the same year, the National Library of Scotland was established by Parliament.

Construction of the new building on George IV Bridge, on a site previously occupied by the Victorian Sheriff Court, began in 1937. Completion was delayed by the outbreak of the Second World War and it was opened by the queen in 1956.

The architect was Reginald Fairlie, who described the building as a 'frigid serenity'. The austere frontage to George IV Bridge is windowless to cut the transfer of traffic noise into the main reading room, which is top-lit by cupolas, and the building depends for

The National Library.

The National Library – Causewayside annexe.

its character on its elegant proportions. The bas-relief sculptures on the facade by Hew Lorimer represent the arts and sciences: Medicine, Science, History, the Poetic Muse, Justice, Theology and Music.

There are seven floors below the George IV Bridge level, with 50 miles of book storage. However, in 1989, due to the demand of the ever-expanding collection, the library takes in

around 4,000 new publications every week – an annexe was opened in a new building on Causewayside in 1989 (with a later phase in 1995).

The Causewayside building was designed by Andrew Merrylees, a former partner in the architectural firm of Basil Spence, Glover and Ferguson. Its bold steel, stone and glass tower dominates the corner of Causewayside and Salisbury Place. The design is functional, based around a modular bookshelf length of 900mm with services kept to the edge of the building, allowing maximum space for storage of the collection. The complexity of the structure was a factor in the deterioration of the fabric of the building and the need for a recent major renovation scheme.

## 4c. National Museum of Scotland, Chambers Street

The foundation stone of the Industrial Museum of Scotland on Chambers Street was laid on 23 October 1861 by Prince Albert – his last public act. It housed a vast collection devoted to natural history, industrial art and the physical sciences. Additions were made in 1874 and 1889. In 1866, it was renamed the Edinburgh Museum of Science and Art and in 1888 became the Royal Scottish Museum. In 2006, The Royal Scottish Museum was merged with the adjoining Museum of Scotland as the National Museum of Scotland.

Many of the museum's original exhibits were donated by the University of Edinburgh and there is a bridge over West College Street connecting the museum to the Old College. It seems that the students would often use the bridge to pop into the museum to borrow or rearrange the exhibits. At some time in the 1870s, the students procured a store of drinks that had been stored in the bridge by the museum and shortly after the entrance to the bridge was closed off.

The aim of the museum's original architect, Captain Francis Fowkes of the Royal Engineers, who also designed the Royal Albert Hall, was to maximise natural light in the building and the vast, 82-metre-long Great Hall has a magnificent, lofty 21-metre-high glass roof modelled on the Crystal Palace.

The Industrial Museum of Scotland.

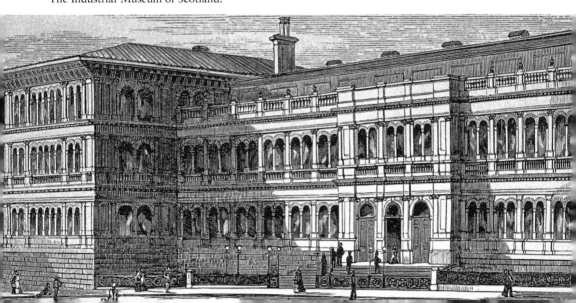

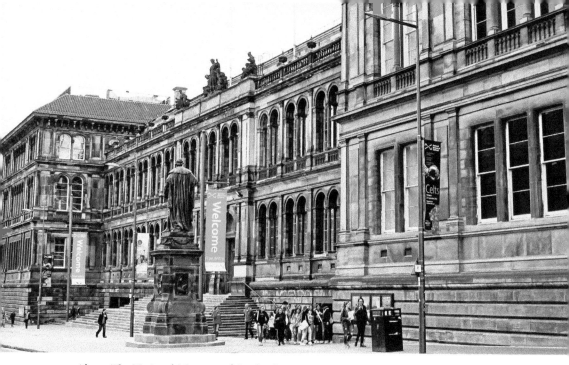

*Above*: The National Museum of Scotland.

*Below*: The 1990s extension to the National Museum of Scotland.

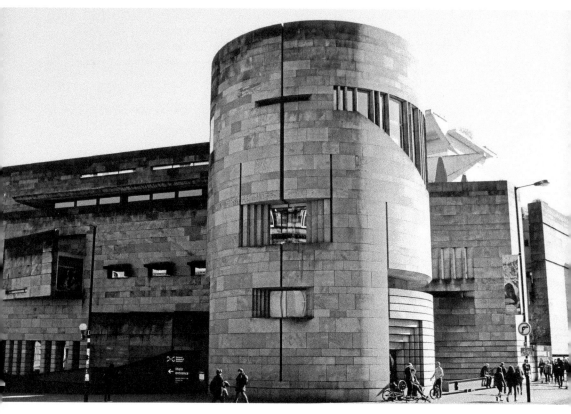

The building underwent a major refurbishment and reopened in July 2011 – many locals have since lamented the loss of the fish ponds, which were a much-loved feature of the Great Hall.

The late 1990s extension to the museum, built as the Museum of Scotland, combines ashlar cladding with a bold massing of diagonals and incisions, and a prominent corner round tower, intended to reflect the Half Moon Battery of the Castle and refer to early Scottish traditional broch designs.

## 41. George Heriot's School, Lauriston Place

George Heriot's School, with its pinnacled towers and turrets, is a magnificent example of Scots Renaissance architecture. It is embellished with an abundance of sophisticated seventeenth-century stone carving – with the exception of two similar windows, the elaborate stone mouldings over the windows are unique. It was the first major building outside of the confines of the Flodden Wall and the north elevation, which faces the town, was intended as the principal facade.

The school is named for George Heriot (1563–1624). Heriot trained in the family business as a Goldsmith and after completing his apprenticeship, set up premises in the Luckenbooths, which stood on the north side of St Giles. His business prospered and by 1588 he was elected to the town council and the Edinburgh Incorporation of Goldsmiths.

One of his regular customers was the jewellery-loving Anne of Denmark, the wife of King James VI of Scotland, and Heriot was appointed the royal goldsmith. In 1603, at the time of the Union of the Crowns, he moved to London with the Royal Court. His considerable

George Heriot's School.

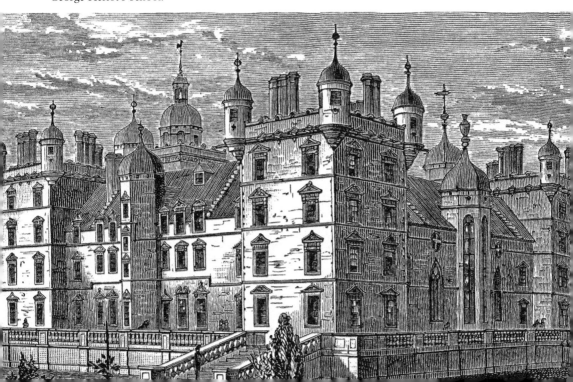

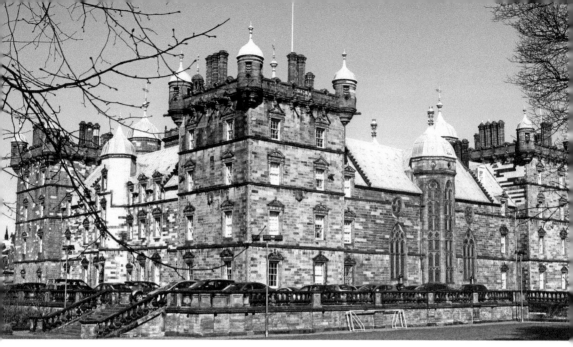

George Heriot's School.

wealth was based on his activities as a goldsmith and as a moneylender to the royal family and their court. A carved panel in the frieze over the entrance to the school depicts Heriot as a goldsmith in his workshop.

His nickname, 'Jinglin' Geordie', was based on the large quantity of coins that he carried in his purse. In his will he left the bulk of his estate to establish George Heriot's Hospital as a charity school for the 'education and nursing of the poor orphans and fatherless children of decayed burgess' of Edinburgh'.

Construction started in 1628, under the supervision of William Wallace, the king's master mason. However, work was postponed due to delays in the collection of debts due to Heriot's estate. In 1650, when the building work was nearing completion, it was taken over by Cromwell's army for use as a barracks and hospital. The building finally opened for its intended purpose in 1659 with thirty pupils. In 1886, the original hospital use ceased and it was renamed George Heriot's School.

A statue of Heriot in the school quadrangle has a Latin inscription that translates as 'This statue shows my body, this building shows my soul'. He is also shown holding a model of the school in a statue on the Scott Monument and his name is commemorated in the Heriot-Watt University.

## 42. University of Edinburgh Old College, South Bridge

The Old College of the university is one of the most notable and important academic buildings in Scotland.

The foundation stone of the new building for the University of Edinburgh on South Bridge was laid in November 1789. The existing university buildings on the site were in a dilapidated condition and badly in need of replacement. The design by the renowned

architect Robert Adam included two internal courtyards and it was intended as the centrepiece of an ambitious overall plan, which was never achieved. Work began in 1789, but was halted in 1793, with only the north-west corner and main frontage completed, following the death of Adam and the outbreak of the Napoleonic War. A carved-stone panel above the main entrance commemorates 'Architecto Roberto Adam'. In 1818, William Playfair completed the building by retaining much of Adam's design, but with only one large colonnaded quadrangle.

In 1887, the landmark dome, which had been part of Adam's original design for the college but had been left out to reduce costs, was added. The dome is crowned by the Golden Boy – a statue of Youth holding a torch and symbolising knowledge.

The magnificent quadrangle at the Old College was re-landscaped in 2010 with a new lawn – in previous recent years it had been used as a car park. During the landscaping work, the remains of an early library with old scientific equipment, believed to have belonged to the eminent chemist Joseph Black, was found.

The site of Old College was the Kirk O'Fields in the 1500s where, in February 1567, certain Scottish nobles planted barrels of gunpowder with the intention of killing Lord Darnley, the second husband of Mary Queen of Scots, who was lodging in the house.

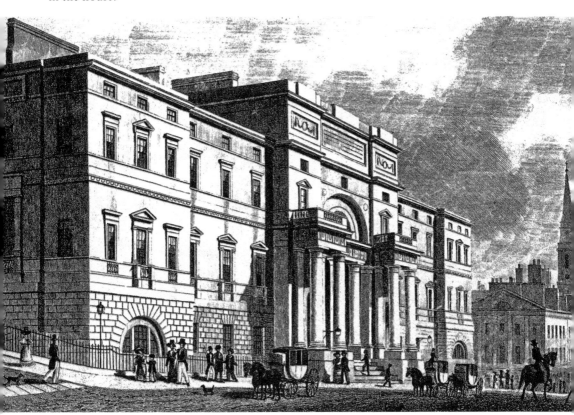

The Old College.

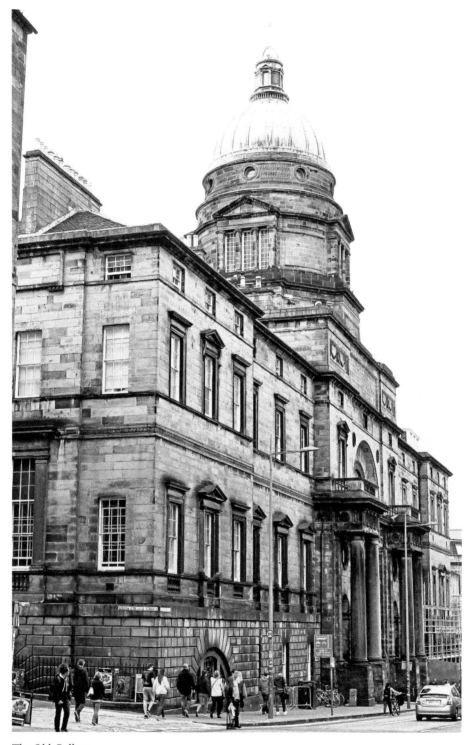

The Old College.

## 13. Surgeons' Hall, Nicolson Street

The Royal College of Surgeons of Edinburgh is one of the oldest surgical institutions in the world and has its origins in 1505, when the Barber Surgeons of Edinburgh were formally admitted as a Craft Guild of the city – the charter of incorporation required that members be literate and skilled in anatomy and astrology. In 1647, they established their first permanent meeting place in rooms in a tenement in Dickson's Close. In 1648, the surgeons passed an act restricting membership of the guild to barbers who were qualified in surgery. As they expanded, they required a building with an anatomical theatre and in 1697, they moved into the Old Surgeons' Hall in High School Yards. In 1778, King George III granted a new charter giving the surgeons' corporation the title 'The Royal College of Surgeons of the City of Edinburgh'.

By the beginning of the nineteenth century, they had outgrown the High School Yards building and additional space was required for the large collection of pathological specimens, including a full-sized elephant, which had been gifted to the college.

A site on Nicolson Street, occupied at the time by a Riding School designed by Robert Adam and built in 1764, was acquired and William Henry Playfair, one of the leading architects of the time, was commissioned to design the new building. The Greek

Surgeons' Hall.

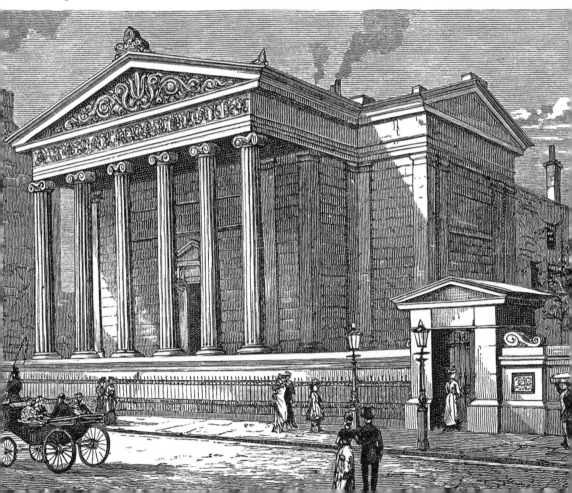

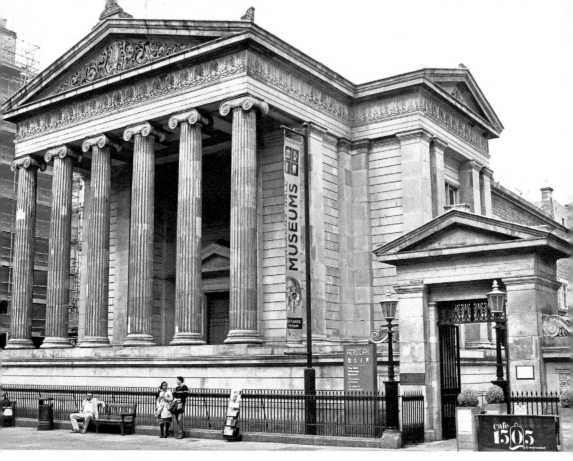

Surgeons' Hall.

Revival-style Surgeons' Hall, with its massive Ionic-columned portico, opened in July 1832. In 1851, Queen Victoria granted a new charter giving the college its present title.

The museum in the building has an intriguing collection of pathological specimens.

## 44. The Festival Theatre, Nicolson Street

The site of the Festival Theatre has been occupied by a succession of circuses and performance halls since 1830 and is Edinburgh's longest-serving theatre venue.

The creation of what was to be a magnificent new theatre on the site was a partnership between two of the great men associated with the theatre at the time - Sir Howard Edward Moss (1852–1912), a major theatre entrepreneur, and the celebrated theatre architect Frank Matcham (1854–1920) – 'Matchless Matcham'.

The new Empire Palace Theatre opened on 7 November 1892. It was an immensely impressive venue described as 'an edifice of magnificent proportions … a temple of amusement of a character hitherto unknown in Scotland'.

The Empire Palace also has a distinguished place in the history of cinema in Scotland, as the first venue in the country where moving pictures were shown. The date was 13 April 1896 when cinematographe equipment developed by the Lumiere Brothers was used to project animated images during a variety show at the theatre.

When the Great Lafayette, Sigmund Neuburger, arrived for a two-week season at the Edinburgh Empire Palace in May 1911, he was the most famous magician in the world.

Lafayette lived as a bachelor recluse with a small cross-bred terrier named Beauty, who had been given to him by Harry Houdini. Lafayette's spectacular show opened to packed houses at the Empire Palace on 1 May 1911. On 4 May Beauty died of apoplexy, caused by overfeeding. Lafayette was grief-stricken and was given permission to have the dog interred at Edinburgh's Piershill Cemetery, with the strict provision that he agreed to be buried in the same place. On Tuesday 9 May, as the Great Lafayette took his bow at the end of the show, a lamp fell into the scenery. The fire curtain was lowered and the audience escaped unscathed. However, by this time the backstage was an inferno. There were ten fatalities, including the Great Lafayette. On 14 May 1911 the Great Lafayette's ashes were interred at Piershill Cemetery, beside Beauty.

By 1927, the Empire Palace was beginning to look unfashionable and was suffering from competition from the development of cinemas. In November 1927, the theatre closed and was largely rebuilt to a design by the prominent theatre designers William and Thomas Milburn. The new Empire Theatre (the word Palace was dropped from the name), with its art deco façade, reopened on 1 October 1928.

By the 1950s, the increasing popularity of television meant that it was no longer necessary to leave home for a night's entertainment. This resulted in dwindling audiences

The Festival Theatre.

for theatres. In 1962, the Empire closed, was sold to Mecca and by March 1963 reopened as the New Empire Casino to cater for the new fad of bingo.

In 1992, bingo was falling out of favour and Mecca was having financial difficulties. The local authority negotiated the purchase of the building from Mecca and it was leased to the Edinburgh Festival Theatre Co. The old frontage was replaced with a stunningly modern concave glass and steel façade, which forms a glowing night-time landmark on Nicolson Street and encloses the magnificent 1928 auditorium. The theatre reopened on 18 May 1994 as the Festival Theatre, which is now one of the UK's leading theatrical venues.

## 45. University of Edinburgh Library, George Square

George Square was developed in the 1760s and was the first building scheme of any significant size outside of the confines of the overcrowded Old Town, and a forerunner of the New Town. The design of terraces with individual houses was a new idea in Edinburgh, where flatted tenements were the norm. The layout of the houses around a central semi-private garden was also a relatively new concept in Scotland. The scale and unity of its design made it an architectural landmark in the city.

It was an immediate success and proved popular with Edinburgh's more affluent citizens – No. 25 was the childhood home of Sir Walter Scott. For a time George Square was the most fashionable residential area in Edinburgh, but by 1800 it had been eclipsed by the New Town.

The University of Edinburgh promoted plans to integrate the scattered departments of the university, and to redevelop George Square and a wider part of the South Side as early as 1945. The university believed that the reconstruction of the Square was the only practical solution to their need for expansion.

Fierce debate about the proposals went on throughout the 1950s. Planning permission was granted in 1956, but mounting opposition to the scheme resulted in a public inquiry in 1959. The Historic Buildings Council then indicated that they considered George Square interesting, but not comparable to the quality of Charlotte Square and the technical advice was that the buildings were too dilapidated for reuse. The fate of the historic buildings on George Square was sealed and early in the following decade the redevelopment went ahead – only the west and part of the east side of the original eighteenth-century square were retained.

In the face of a public outcry, modernist blocks replaced many of the charming old Georgian buildings on the square. The new buildings included the David Hume Tower, the William Robertson Building, the Adam Ferguson Building and the George Square Theatre by Robert Matthew Johnson-Marshall & Partners, and the Appleton Tower by Alan Reiach, Eric Hall & Partners.

The University of Edinburgh library on George Square is a key work of Sir Basil Spence, Glover and Ferguson and is one of the most important Scottish buildings of the 1960s. Sir Basil Spence (1907–76) was one of the most important and versatile British architects of the post-war period. He was prolific in Edinburgh and his practice is associated with the design of a number of important post-war buildings in the city. He produced a development plan for the university expansion in George Square as early

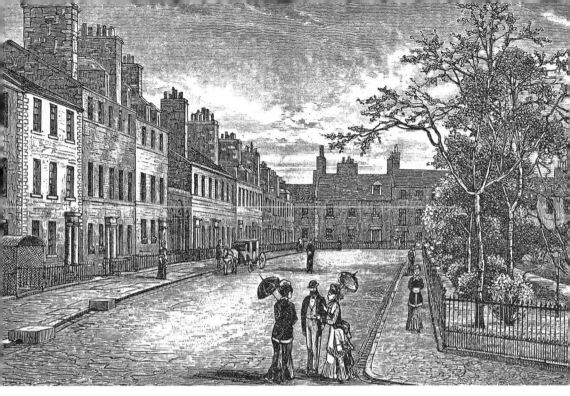

*Above*: George Square in the nineteenth century.

*Below*: The University of Edinburgh George Square Library.

as 1955. The plan, even at this early stage, showed the library on the quieter south-west corner of the square. However, it was another decade before work started on the building and it opened in 1967.

The university's brief was for a building that could hold two million books and cater for up to 6,000 students on a daily basis. The building is eight storeys high and each floor is an acre in area – making it the largest university library in Britain. The bulk of the building is cleverly disguised by the horizontal projecting cantilevered balconies, which also provide shading from the sun. It received a RIBA award in 1968, a Civic Trust commendation in 1969 and was listed at Category 'A' in 2006, denoting its national importance.

## 46. The Chapel of Saint Albert the Great, George Square

The Chapel of Saint Albert the Great was completed in 2012 for the University Chaplaincy and Order of Preachers. It is located in the back garden of one of the Georgian town houses on George Square and is a remarkable place of worship.

The elegant curved-oak roof is supported by four 'steel trees'; the west wall is glazed, linking the chapel to the surrounding garden; and the solidity of the east masonry wall provides mass to the lightness of the other building elements.

The chapel won numerous prestigious architectural awards in 2013.

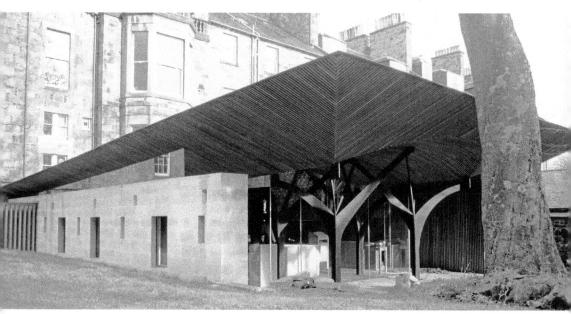

The Chapel of Saint Albert the Great.

## 47. The Scottish Widows, Dalkeith Road

In 1970, the Scottish Widows Fund and Life Assurance Society bought a site, beside Holyrood Park, on Dalkeith Road, for their new head office. The site had previously been occupied by Thomas Nelson's Parkside printing works.

The Scottish Widows.

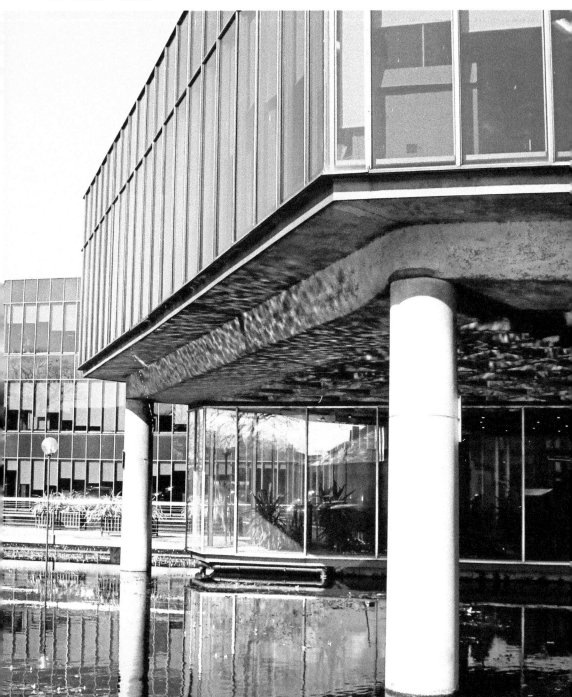

Sir Basil Spence, Glover & Ferguson were commissioned as architects for the new building in 1972. The striking design was planned to be in harmony and scale with the site and its surroundings. It incorporates a series of interlocking hexagonal prisms varying in height from one to four storeys, which were intended to act as a geological analogy, reflecting the structure of the basalt columns of Salisbury Crags – from where the design is best appreciated.

The building, which is finished in a continuous curtain wall of brown solar glass, stands partly in a moat-like pool and the main access from Dalkeith Road is over a bridge. Dame Sylvia Crowe, the leading landscape architect of the period, was commissioned to design the grounds.

The office was opened in March 1976 and its status as a building of international importance was recognised by the 1977 RIBA Award for Scotland and the American Landscape Award in 1978.

## 48. Mortonhall Crematorium, Howdenhall Road

The multi-denominational Mortonhall Crematorium dates from 1967 and is one of Edinburgh's most iconic post-war buildings. It has been said that the 'spirit of Le Corbusier is reflected in the building, and that there is a stylistic debt to Le Corbusier's Ronchamp in the theatrical use of wall-planes and shafted light' (Brian Edwards - *Basil Spence 1907-76*, 1995).

Mortonhall Crematorium.

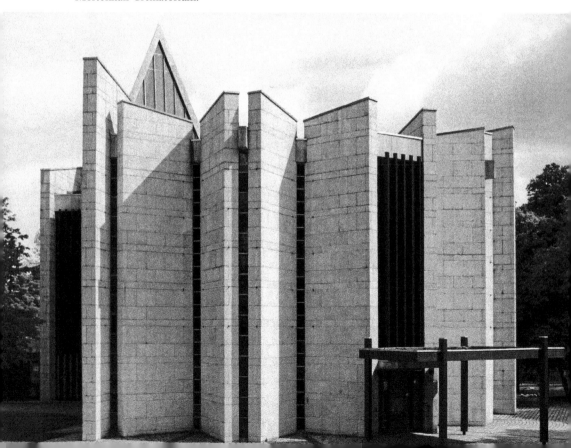

The dramatic massing of concrete-slab walls of varying heights provides a dramatic vertical geometry. The windows are lofty narrow slits with multi-coloured glass, which provide striking reflections in the plain-white-painted interior.

The crematorium has been voted one of the 100 best modern buildings in Scotland and is Category 'A' listed.

## 49. Prestonfield House

Prestonfield House is an example of one of the many country houses on small estates that ringed Edinburgh from the middle of the sixteenth century. It lies on the south side of Holyrood Park, which forms a dramatic backdrop to the house.

The estate was the site of a Cistercian monastery established in 1150 and known as Priestfield. Over the following centuries there were a number of owners until, in 1671, it was sold to the Dick family, who were associated with the estate for a number of generations. On 11 January 1681, the original building on the estate was burnt down by students in an anti-Catholic riot.

The new Prestonfield House was commissioned by Sir Alexander Dick and built in 1687 from designs by the celebrated architect Sir William Bruce of Kinross, the king's Surveyor-

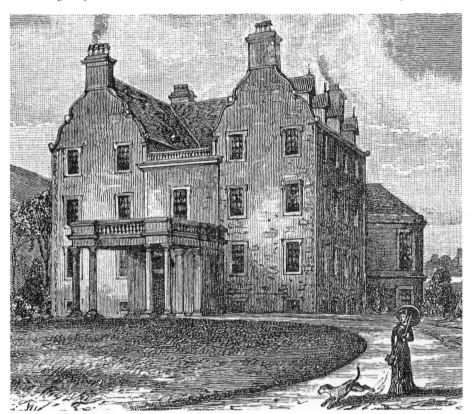

Prestonfield House.

General and the architect for the Palace of Holyroodhouse. (Robert Mylne, the king's Master Mason, is also cited in some sources as the architect.)

The original U-plan house has had many additions over the years. The elegantly symmetrical main west front has twin-curved 'Dutch' gables and the predominately white harled walls contrast with the grey stone dressings. The Roman Doric porte cochere dates from 1818.

The estate was originally much larger – stretching as far as Dalkieth Road, taking in parts of the adjoining golf course and Duddingston Loch.

Sir Alexander Dick (1703–85), grandson of Sir James, was a distinguished doctor, who succeeded to the estate in the 1740s. Sir Alexander entertained many famous personalities of the time, including Allan Ramsay, the poet; and his son, also Allan, the famed portrait painter; David Hume; James Boswell and Dr Johnson.

Sir Alexander pioneered the cultivation of rhubarb on the estate and was one of the earliest promoters of the pharmaceutical value of the vegetable – in 1774 he was awarded the Gold Medal of the Royal Society of Arts for the cultivation of a type of rhubarb for medical purposes. It is recorded that Dr Johnson, some months before his death in 1784, requested a supply of rhubarb from Sir Alexander to improve his health. Sir James Dick, Alexander's grandfather, was Lord Provost of Edinburgh from 1679 to 1681. He financed, at his own expense, the cleaning of Edinburgh's streets and the manure collected was used to fertilise the grounds of Prestonfield – which goes some way to explain why his grandson's rhubarb thrived in the fields of Prestonfield.

Prestonfield House was converted for use as hotel in the 1960s and since 2003 has operated as a prestigious five-star boutique hotel. The interior retains many fine original features, which have been enhanced by the decoration and fittings of the hotel.

Prestonfield House.

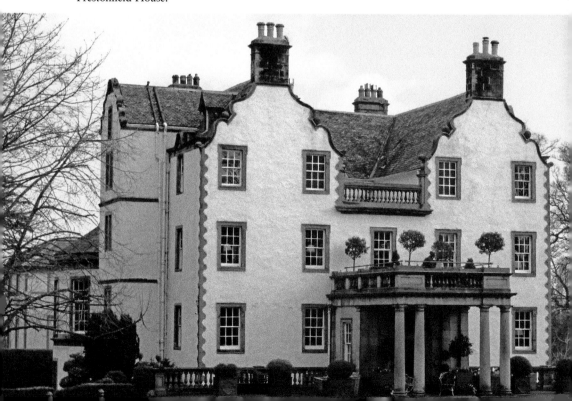

The circular-plan stable block was added by Sir Robert Keith Dick and dates from 1816. It was designed by James Gillespie Graham and is now used as the hotel function suite.

## 50. Craigmillar Castle

> Of cool poetic joy, I bent my way
> Tow'rd a majestic Castle's ruins wide;
> Within whose gates once royalty bore sway,
> And for a season laid its cares aside.
> *Craigmillar Castle: an Elegy, John Pinkerton, 1775*

Edinburgh's other citadel, at Craigmillar, is one of the best-preserved medieval castles in Scotland. It has its origins in a late fifteenth century tower house built by the Preston family – the local feudal barons – which forms the core of the castle. The Preston family carried out numerous extensions to the original building over the centuries. The curtain wall surrounding the tower house dates from around 1508 and additional outer walls were added in 1511. The castle was repaired and enlarged after being burned by English troops in 1544 during the Rough Wooing – in which Henry VII attempted to force a marriage between the infant Mary, Queen of Scots, and his son Edward to create an alliance between Engand and Scotland.

Craigmillar Castle.

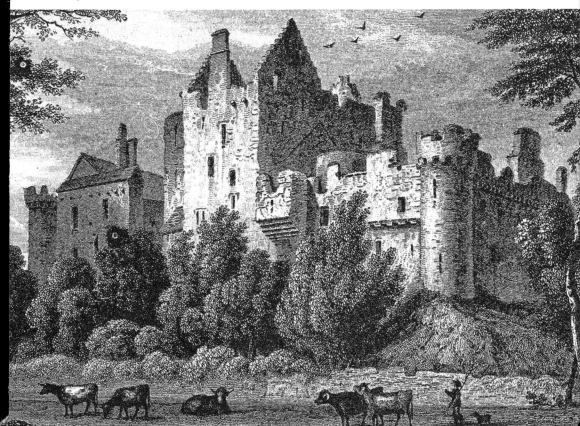

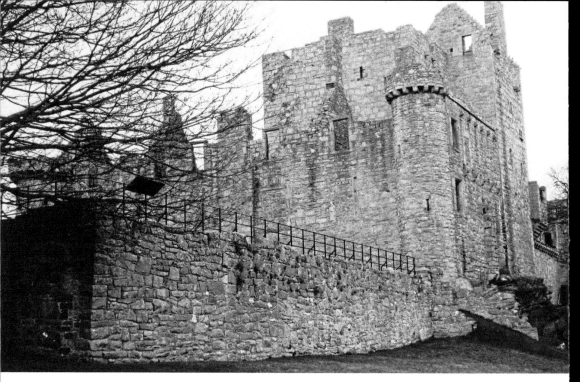

Craigmillar Castle.

The castle is renowned for its association with Mary, Queen of Scots. The queen stayed at the castle between 20 November and 7 December 1566, while convalescing after the birth of her son, the future James VI. During this time, a group of her nobles signed the *Craigmillar Bond*, a pact to remove her husband, Lord Darnley. Darnley was murdered at the Kirk o' Field on 10 February 1567.

In 1660, the Preston family sold the castle to Sir John Gilmour. Gilmour added the west range as more modern accommodation, but by the early 1700s the Gilmour family abandoned the castle and moved to the newly built Inch House.

The castle fell into disrepair in the eighteenth and nineteenth centuries – it was in a ruinous state in 1775 when John Pinkerton wrote his *Elegy to Craigmillar Castle*. It was taken into state care in the 1940s, restored in 1951 and is now maintained by Historic Environment Scotland.